MW00810318

Dear Ménière's

Letters and Art
A Collection

A Global Ménière's Project
Created by people living with Ménière's Disease
Collated by Julieann Wallace, Anne Elias,
Heather Davies, Steven Schwier

Lilly Pilly
PUBLISHING

Dear Ménière's ~ a collection of letters and art
Copyright © 2023
Published by Lilly Pilly Publishing

This is a work of letters and art created by *humans*. You will find American and English spelling and punctuation in the letters, as this is a book created by people around the world, and so, the spelling from their countries is used. Forgive us for any errors. We will update the book as they are found. Individuals retain copyright for their letters, poems and art.

Ménière's disease is a dastardly debilitating vestibular condition that causes vertigo, hearing loss, tinnitus, brain fog, fullness of the ear, balance difficulties. It is life changing.

Book Cover design by Julieann Wallace
Cover art paperback by 123RF: Typewriter by 123RF Maystra ID 104064292
Inside cover art by Shutterstock: Benjavisa ID 781838023
Cover art hardcover by Shutterstock: Serge Ka ID 347619089
Typewriters by 123RF gmm2000 ID 89317154

1st Edition
ISBN: 978-0-6451581-6-8 (hardcover)
ISBN: 978-0-6451581-7-5 (print book)
ISBN: 978-0-6451581-8-2 (eBook)

A catalogue record for this book is available from the National Library of Australia

We would like to acknowledge the following organisations for their support of people who live with Ménière's Disease.

www.menieresresearchaustralia.com www.american-hearing.org https://www.menieres.org.uk prospermeniere.com

We are mindful of those who also have incurable diseases or are walking on the path of a diagnosis that is life changing. This book never aims to undermine the severity of anyone else's illness, disability or journey. We all deal with life with different tolerances, attitudes and thresholds. It is our hope that this book will bless those with Ménière's disease, help family, friends, people in the medical professional and disability organisations understand the affect of the disease physically, socially, psychologically, emotionally, and it's quality of life impact.

This book is dedicated to you, Ménière's Monster.
Without you, this book would not exist.
You certainly don't deserve a book but you've given us no choice.
Through the anxiety, depression, hearing loss, tinnitus, vertigo,
and all your evil symptoms, here's your book.
I hope you like it, and we want you to know,
it brought us great healing.
So here's your book, now you can stick it up your a**!

Sincerely not yours,

The Worldwide Ménière's Community

Prosper Ménière Society

The Prosper Ménière Society, founded in 1981 by Dr. Irv Arenberg of the International Ménière's Disease Research Institute (IMDRI) in Colorado, USA.

Ménière's disease continues to fascinate scientists as much as the misery it can cause those afflicted. Named after Prosper Ménière (1799-1862), The Society's primary goal is promoting academic dissemination and discussion of basic and clinical research data and all aspects of inner ear dysfunction, pathophysiology, diagnosis and treatment. It is unique. Most members are clinicians who see patients more as partners unravelling the mysteries rather than mere study subjects. Its primary meeting is held every other year with basic and clinical researchers from otolaryngology, otology/neurotology, neuroradiology and audiology for a week-long program. Invited speakers are able to debate, put forward new ideas as new discoveries come to light and as technology improves, discussing updated theories and re-hashing old ones. The field has now entered a new phase where high definition imaging and inner ear cell types and the genes that encode their proteins can be readily sequenced at DNA level, bringing great promise to those who may be disease susceptible and classified to more granular levels for personalised treatment. With work continuing on a global scale, the future is bright for inner ear research, which will ultimately benefit all humanity.

prospermeniere.com

Foreword

This is a book, a book like so many others—a front cover, pages of information, and a back cover. Books invite you into a world that might entertain, inform, make you laugh or cry, or just help you escape the world you live in for a while. But this is not your ordinary book; it was written selfishly: not for fame, or hope for the New York Times Bestseller List. Instead, this book is the heart of a community exposed; it was written with the blood, sweat and fears of an entire group of people who suffer from the chronic and debilitating illness called Ménière's.

The beautiful souls who contributed to this effort are precious and are at last being heard speaking the truth, their truth, of living with this debilitating and life changing illness. Our contributors share real, raw, sometimes comical, yet very honest letters and artwork from the invisible community of Ménière's sufferers around the world.

When our team of publishers asked for submissions about the effects of Ménière's, we had no idea of the impact it would have on our community. But immediately, person after person started sending in letters and artwork, straight from their hearts. Ordinary people like you and me, people of all ages, genders, social class and geographical differences. Each vulnerable submission, written and drawn with hearts on their sleeves, is a window into how many lives have been disrupted, changed, and even lost in the battle against an invisible monster.

Our brave contributors pulled the curtains back and exposed their life altering journeys for what they are, a constant battle against a disease that takes so much from each of us, sometimes everything. That is the truth about which this population of silent sufferers found their voices and spoke up. And speak up they did.

We cried, we laughed, we rejoiced in the content that follows, but most of all, we feel privileged to give a voice to the unheard, the unseen, the invisible who fight this dreaded disease day after day, minute by minute, yet still continue to battle and live the best lives they can.

Thank you to everyone who submitted their hearts to us. I hope we have done you proud in this book, because we are proud of every one of you. And we hope for you all, more good days than bad.

—Steve Schwier, author of On the Vertigo

Contents

Ménière's Disease Celebrity Roll Call

Aaron Reiser - artist
Alan Shepard - first American in space and fifth to land on the moon
Andrew Hugill - Professor - music composer
Andrew Knight - Australian TV writer & producer of film & television
Ayumi Hamasaki - Japanese pop star
Brian Evans - university administrator
Chris Packham - Wildlife star
Chris Potter - saxophonist and band leader
Dan Buettner- American explorer, educator, author, public speaker
Dan Carlson - journalist
Dana Davis - author and ghost buster
Dana White - President and CEO of the Ultimate Fighting Championship
Daniel Pancy - photographer
Dave Corman - Nearly Neil guitarist
David Alstead - classical pianist
David Copithorne - PR and marketing
Edeltraut L. Scheffler Plath - poet
Elizabeth Anne Steward - community service person and Ménière's Disease advocate.
Emily Dickinson - American writer and poet
Erin Kelly - author
Guy Kawasaki - host of Remarkable People podcast/Chief Evangelist of Canva
Huey Lewis - American singer, songwriter, and actor.
James Page - Sivu - musician
Jane Nichols - chancellor, University of Nevada.
Jessica Williams - actress and comedian
Jessie J - singer
Jonathan Swift - Anglo-Irish satirist, writer, and poet
Judy Carrow - disaster volunteer
Kaela Davis - American professional basketball player
Katie Leclerc - actress
Kristen Chenoweth - actress
Kuriyama Hideki - Japanese baseball player and manager
Kyle Walpole - climber
Les Paul - American guitarist, songwriter, luthier, and inventor of the electric guitar
Lisa McDonald - Irish politician

Mandy Stefanczak - fitness competitor
Martin Luther - theologian and religious reformer
Mary Geneva "Mamie" Eisenhower - wife of President Dwight D. Eisenhower
Max Bygraves - comedian, actor, singer
Meg MacDonald - television journalist
Mike Reilly - umpire
Nancy Freudenthal - First Lady of the State of Wyoming
Noelle Liedtke - wife of Mike Liedtke - athlete
Patrick Flores - Archbishop of San Antonio
Patty Spitler - broadcast journalist
Paul Jansen - musician
Peggy Goldwater - wife of Senator Barry Goldwater
Peggy Lee - American singer, songwriter, composer, and actress
Randy Thurman - multi-talented artist
Ryan Adams - American singer-songwriter
Stan Gallimore - drummer
Steve Francis - Basketball player
Steven Barrie-Anthony - journalist
Tim Conley - Professional golfer
Vincent Van Gogh - Dutch painter -

> The modern diagnosis for Van Gogh's illness -
> "*My health during the intervals [between "vertige"],
> and my stomach are so much better than before,
> that I believe it will still take years before I am
> quite incapable [incapacitated] which I feared in
> the beginning would be the case immediately. In the
> beginning, I was so defeated, that I had no desire
> even to see my friends again and to work, and now
> the desire for these two things is stirring, and then
> there is the fact that one's appetite and health are
> perfect during the interval.*"

And others ...

be *kind*

for everyone you meet
is fighting a battle
you know nothing about ...

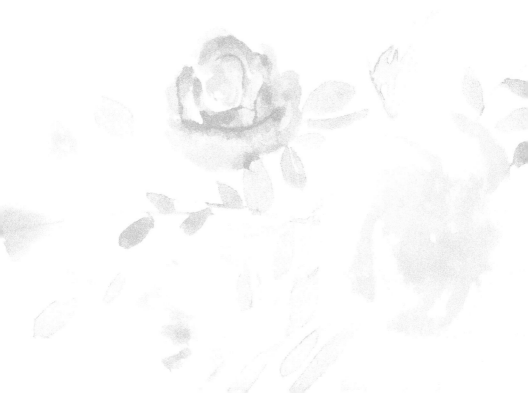

Dear *Incurable Disease*,

That's you, *Ménière's*. There's a call out for submission for letters and art about you.

Apparently you're the focus of a new book, a collection of expressive writing and a visual feast of art ~ creativity.

Surely you don't deserve such attention in this way?

Who do you think you are?

We'll see …

The letters?

What do you think they will say about you?

How *kind* you are?

How *popular* and *well-liked* you are? Generous?

Do you think you'll be thanked?

We'll see …

And the art?

What on earth would you look like on the canvas? In a photograph? Or other creative art mediums? Ha, a sculpture of you would be interesting!

Which of your many torturous skills would they show? Your vertigo? Tinnitus? Hearing loss? Brain fog? Unbalance? Nausea? Hyperacusis? How you shatter a person? The darkness you bring?

Do you think you'll be beautiful and lavished with love in each of those carefully placed paint strokes?

Will you be depicted up on a pedestal all high and mighty?

Will you be signing your name with success, or shame?

Will the capturing of your existence in visual form be so exceptional that an entire gallery will be dedicated to you, is that what Vincent van Gogh's art galleries do? Or will you be uncovered, showing the monster you truly are?

We'll see …

Ménière's, you're finally being called out for the atrocious bully that you are.

Fingers are being pointed at you for torturing people with vile, violent vertigo, insanely loud tinnitus, nausea, hyperacusis, deafness and loss of balance. So debilitating are your attacks that some cannot find the strength to live with the symptoms anymore. How dare you?

Are you proud of the quality of life rating of **6** days from death as stated by the American Otological Society (AOS) in their paper - *Meniere's Disease Quality of Life (13 May 2000)* - with your repulsive, incredible fast room spinning vertigo that lasts for hours, sometimes days?

Fists are being shaken at you for your devious ways, hiding in the inner ear that is hard to get to. What a dastard—a dishonourable and despicable disease!

Voices are being shouted, louder than our unremitting, loud tinnitus, to call you out from your cowardly darkness and into the light so you can be seen in all of your ugliness.

You thief. Stealing happiness, livelihoods, passions, friends, confidence, hearing, joy, money, a normal quality of life, bringing us to our knees to search for the missing pieces of us.

Ménière's disease. *Debilitating. Life changing.*

Do you really think there is no cause, no cure?

We'll see …

Ménière's research is discovering your mischievous ways. Researchers are planning an attack to take you down. How joyous that day will be when the doctor will say, 'You've got Ménière's disease. We can fix that!'

Julieann Wallace

MENIERE'S RESEARCH AUSTRALIA AMBASSADOR

Ménière's disease since 1995, Cochlear Implant 2020, Secondary Teacher, Author, Artist, Terrible cello player

Way Down I Go
Colin (That Monster Ménière's)
Ink on paper

This piece took around six hours, spread over three weeks. Having vestibular migraines alongside Ménière's disease makes drawing a hard task for me, which is frustrating as drawing has been a friend of mine since a child, and unfortunately, it is not something I do very often anymore.

To get this piece finished I would draw for one hour and take two breaks within that hour, then I would suffer with a migraine and strained eyes for up to 48 hours after. So it was tough going and very emotional for myself and those around me once I finally finished.

The artwork is my way of representing a few aspects of having MD. The fluids in the ear being the main cause of this disease. The feeling of having blocked ears often much like we get from going swimming. Living with vestibular problems has taken me to such low depths in many ways, I often feel I am drowning and sinking in life. I'm always waiting for those days/weeks of lesser symptoms or remission to get my head above water and breathe again, those moments to catch some air and compose myself before I go under and into the deep once more.

Often I have a song in my head when creating art, it's like a motivation and inspiration to guide me along. The song to this drawing is by an English artist called *Låpsley*, and the track is called *Drowning*. I will leave you with the lyrics to the chorus, I'm sure a lot of people will relate to it.

> *You said I could always swim so far*
> *I was like a fish in water*
> *I could always swim so far*
> *I was like a fish in water*
> *So why am I Drowning, drowning, drowning, drowning?*

Colin (That Monster Ménière's) Diagnosed 2019
Instagram: @that_monster_menieres

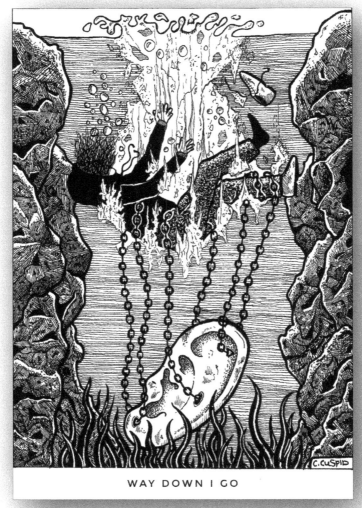

WAY DOWN I GO

Way Down I Go
Colin (That Monster Ménière's)
Ink on paper

Ode to a *Jealous Lover*

My jilted lover. Thou art a hearty bitch.
Why am I like this? Nobody else is like this.
Who lets a jilted lover in his own bed?
Who allows a demon to reside in their own head?
Why do I share everything I have with you?
Do I bring this on myself or am I just cursed?
Thou art a jealous lover.
You hate when I don't pay attention to you.
You find your way into every living fabric of my being.
Is giving me space and time too much to ask?
I'll never be alone again. I'm sure you'll see to that.
You want to be a part of everything I do.
And then you fuck it up with your petty jealousy.
I can't spend an evening with my wife without you.
I have lost friends because you have me tied around your little
fucking finger.
Thou art a petty lover.
What makes me so special that you want me all to yourself?
I wake in the morning to you calling out to me.
The ringing and the roaring. Selfish whispers.
I'm still here, you say?
When I lay down to sleep and close my eyes.
You are the last thing I have to hear before drifting off to an
unnerving sleep.
Why me? What do you want? You're an evil stalker.
Thou art a jealous lover.
It angers you that I have my own passions, my own interests,
my own friends.
But no, you want to be a part of all that too.
Thou art a fickle lover.
You interrupt any happiness I have because you have to be the
center of my world.
What's so special that you need my undivided attention every
day all day?

If I crack a smile, you're there to tear me down and remind me I'm not my own person.

You scoff at me and ridicule me, making me feel less than.

This letter is to you, my jealous lover.

And the sad thing is, I cannot walk away.

I don't have that choice and where would I go anyway? You'd find me and continue this relationship of anarchy.

What did I do to deserve your treatment? You've invaded my every fiber and confused my thoughts, as I drop into isolation again and again and again and again, forever and ever.

When I'm alone, you demand my full attention. You exhaust me.

When I'm with friends, you pull me away. Not letting me forget you are there.

You've trapped me in bed for days. Whispering in my ear, *I'm here for you, my love.*

You cherish our time together like no other. The happiness you feel is pathetic, petty, and jealous. What did I do to you to deserve your undivided attention?

You think you know me better than I know myself, but you don't. If you did, you would realize I want nothing to do with you.

Yet thou art a dizzying lover.

You smother me with attention I don't want. You're delusional if you think I enjoy this relationship, but here I am still tied like a knot on a wayward ship.

I've asked and prayed for you to leave me alone so often I'm hoarse in the throat.

Tears are all I have left. But I'm sure, this is your goal. You want complete ownership over me.

Thou art a jealous lover.

Yours untruly,

Steven Schwier

Ménière's disease since 2012
Author, musician
Instagram: @onthevertigo
Facebook: Ménières: On the Vertigo
www.onthevertigo.com

VeDΛ
AMBASSADOR

The Doctor
Colin (That Monster Ménière's)
Digital photography

This image is pretty straight forward, it is my take on living with MD, and the world of medication and doctors that comes with this life. Ménière's disease was given its name in France by *Prosper Meniere* around the 1860s, but yet here we sit in the 21st century and still have a lot to learn about it, we still have so many why's, we still wait in desperation for a full cure to end this misery. The 1800s were also the same time that the plague doctors started appearing around Paris and Europe, this is why in the photo I have a plague doctor outfit on. I wanted to bring the past medical world into today, to blend the time periods.

The plague doctors were often unqualified medical people that were volunteers, and rarely brought about a cure or any real help for the patient, that last part may sound familiar to a lot of us.

Some people find a great doctor and do get some help with this dizzy and symptomatic life, but an equal amount of us feel we get no help and are not taking seriously by our doctors. We feel near the bottom of the list of the world of being sick. It can feel like visiting a plague doctor in a modern surgery setting. Also, this image is my feelings on the pushing and obsession with medication that comes with living with a chronic illness. I'm a very sensitive person to most meds and supplements I've tried over the years, often they lead to more problems or even worse they make the problem I'm trying to escape more amplified. Not only do I have to live with a broken body, but anything I seem to take to help get through this life puts me in a much worse situation than before. It's frustrating and makes me feel even more helpless and lost compared to others. I've had many discussions with others in this same predicament, I am not alone which does give me comfort. Some of us choose to takes meds, others choose not, and then some of us just can't. This is a lesson that the medical world, the healthy world, and also fellow sufferers really need to understand more. None of us are wrong in our approach through this, we are all trying our best. My wish would be that the medicated and non-medicated should stop pressuring each other. We are in this bobbing and unstable boat together.

Colin (That Monster Ménière's) *Diagnosed 2019*

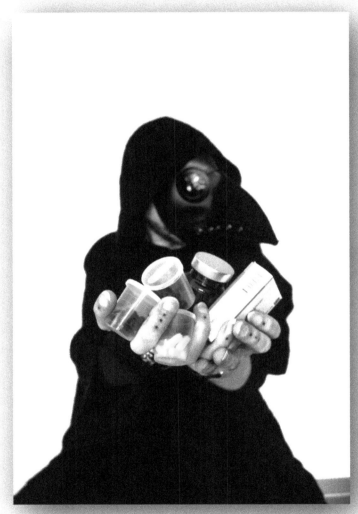

The Doctor
Colin (That Monster Ménière's)
Digital photography

Dear *Ménière's,*

I wish I could stand at the ends of the earth, where the winds blow swiftest, and feel the gentle sway caused by the blowing, not by my lack of balance, and have the winds blow away the tinnitus and the brain fog.

To have, for just one moment again in time, the silence of sound.

The clarity of mind.

To feel energised by life and not drained by it.

I imagine standing on a windswept shore. The noise I hear is the rustle of seagrass, the blowing of the southerly wind, the heave and heft of the ocean. Sea salt and sand pepper my skin. The incessant ring in my ears is quiet, drowned out by the oceans song or swept away, I neither know nor care, I cannot hear it.

The salty air fills my lungs, its brusqueness blows away the ever present fog in my brain. Thoughts, swirling vaguely in my brain, come to the forefront. They take shape, as clear and sharp as the broken shells beneath my feet. I'm not moving through a miasma, I'm as clear as the sun shining through the water that rolls onto the sand and back out again.

Each deep breath clears more fog from my head and returns more of me to myself, as if the real me lives out there in the ocean, waiting to be breathed in on the winds.

I miss who I was.

Kelly

Ménière's disease since 1998

Dear *Ménière's,*

Isolation. That's what you do. Isolated on the bed, on a floor, on a sofa. *Vertigo.* Spinning for hours and hours and hours and hours, unable to move. Holding on for dear life, trying to stop the violent merry-go-round. The nausea. The vomiting.

Isolated on the toilet floor. *Vertigo.* Spinning for hours and hours and hours, unable to move. The cold hard tiles. The stench of vomit, and bowel movements. The nausea. The vomiting.

Isolated in the car, the park, the shopping centre, a place of worship, the amusement park, the beach, on holiday, anywhere, everywhere ... *vertigo.* Spinning for hours and hours and hours, unable to move. The nausea. The vomiting. *The violent vomiting.*

Isolation. That's what you do. Isolated from friends, when you stop us from socialising. Isolated from family events, too unwell to attend. Isolated from work. It's impossible to function with vertigo, and we struggle to hear our colleagues and customers.

Faking being well, feeling isolated. *Trying to fit in,* feeling isolated. Isolated from participating in our own lives ...

Then COVID came, and the world isolated. I smirked because I had perfected isolation. I knew how to survive. *Isolated.* Imprisoned. Restricted from going anywhere or doing anything. Except my isolation had vertigo, tinnitus, hearing loss, depression, brain fog, diet restrictions, unable to watch television or movies or play games because of motion sensitivity, mindless scrolling on social media inflicting a vertigo attack. The wearing of masks stopped us from lip reading. *Isolated,* more. A normal person's isolation during the pandemic looked like a dream holiday ...

But hey, Ménière's. Isolation that feels like solitary confinement - that's what you do. *Undeserved punishment.* After the pandemic, people walked out of their homely prisons, back to freedom, back to their lives lived to their full potential. Freed.

But not me, not with Ménière's ... I believe freedom is coming. That is my *hop*e.

Roseanna

Ménière's disease since 2015

Pieces
Julieann Wallace
Photography, Acrylic paint on canvas, paper, digital

I created this art piece while reflecting on my Ménière's journey since 1995. It's about trying to find the jigsaw piece that is the cause of my MD. It is one cause, or a multiple of causes? What is that one piece that will put it all together so that it makes sense? What is the answer?

The swirls represent the violent vertigo, the circular movement of creating the swirls giving a therapeutic release of the symptom I hate so much. The symptom that disables, debilitates and decommissions people in every facet of their lives.

Ménière's since 1995
Instagram: @julieann_wallace_author
 @myshadow_menieres

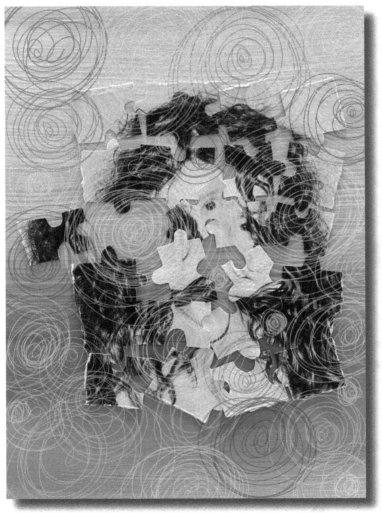

Pieces
Julieann Wallace
Photography, Acrylic paint on canvas, paper, digital

To "My *Ménière's Disease*", You are not *my* Ménière's Disease.

When invited to write a letter to you, I immediately resisted because, who are you to deserve my words? *You have been with me for three decades - why give you more of me*, I thought. You, who startled me out of a deep slumber with vertigo and vomiting and diarrhea at the innocent and pure age of twenty-one. You, who invaded me when my life was about to begin. I was terrified when the doctors said I had you. You became my body snatcher. I cursed you. I fought you. I would not let you take all of me. Follow doctors' orders? *No way!* Those orders were not working, so why bother anyway? I was fiercely stubborn, and my own will (or willfulness) would figure out how to silence you. I would not allow you to enslave me. I promised myself that you would not rob me of a life of joy. You would not take me down. My rage would fuel me.

After the first decade and a half, the vertigo "attacks" diminished. But you did not leave me completely. I continued to experience ear fullness, head popping pressure, hearing loss, dizzy spells, brain fog, tinnitus, crackling sounds and more. You stuck around.

As I aged, I continued to ignore you. I became employed and furthered my career. I played and socialized with my 20-something peers. I pretended you were not there, creeping behind me waiting to strike whenever it served you. I was busy trying to make a beautiful life. But I was never comfortable. I was often symptomatic though I showed no outward signs. I was busy trying to live the life I promised myself. But you affected my emotional and mental health regardless of these efforts. I would fight for my life despite you.

I held onto my dear friends, met my soul mate, and got married. We had three amazing sons. Ménière's, you were no part of that.

Although I created a life of joy - the life I planned for, my techniques to fight you were no longer working. You wore on my emotional and mental health. I masked your sounds with fans and white noise machines.

I self-medicated with alcohol to numb you. I numbed the symptoms that plagued my body; I numbed the emotional toll you inflicted upon me.

Over time, alcohol and sleep were my only reprieve. I realized the energy I used to fight you was wearing on me. I was losing steam and you were now winning. My way of coping-alcoholic drinking - was slowly killing me. I asked God to take me from this earth because living with you was unbearable.

After you spent two decades of my life inside of me, I hit a crossroads in my life. I had nothing left in me. I was depleted of all my energy to live. Fighting you, denying your existence and drinking to cope with the horrid symptoms were no longer serving me.

I had to make a change. All the fight, all the anger, all the resentment I had about you, turned to a place of surrender. I had to surrender to learn how to live with you. I had to stop trying to win. I needed to learn how to live with your presence.

For 11 years, I have been living a beautiful life even though you are still with me. That fight instinct towards you became a peaceful resiliency. Instead of ignoring you, I choose to understand you. By doing so, I know when you may arrive. I do not deny your existence any longer; I am honest with my loved ones when symptoms flare up. My honesty helps them help me. I now choose to take care of myself so that you do not show up as often or as powerfully. Slower living, calming activities like yoga, meditation, prayer, and muscle strengthening exercises have become a new way of living. Also, I finally met with an audiologist for hearing aids. Caring for myself this way improved my quality of life.

My joy became true, authentic joy - not joy to mask resentment for you.

I am fifty now. I hope there is a cure in my lifetime. I am grateful that I am happy while living this new life; this new design for living with a chronic illness.

You almost took all of me, Ménière's. But love and joy are so much more powerful than my anger towards you. If you taught me anything, you taught me that I am resilient.

Despite your continued existence, I found acceptance in my surrendering to you. I forgive you and am grateful I got a second chance to live more comfortably with you. This is how I won.

Love, Sarah

Ménière's 30 years
Podcast: www.sobergratitudes.com/sobergratitudespodcast
sobergratitudes@gmail.com

Links of the Chain
Matty
Metalwork

All the pieces of the Ménière's links finally came together for me. It took many years for me to work out what links I needed to keep in my chain and what links I didn't ...

I don't need stress
I don't need salt
I don't need poor sleep
I don't need dairy
I don't need too much sugar
I do need urea
I do need Serc
I do need Valium
I do need my family
I do need me time

These are the links in my Ménière's chain. They may not be what is in yours. The links of the chain look great on the outside and that's what everyone else sees, but when you are the one who makes the chain you see everything, both the good and the bad.

Ménière's since 1992

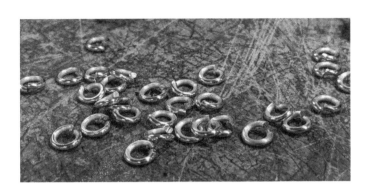

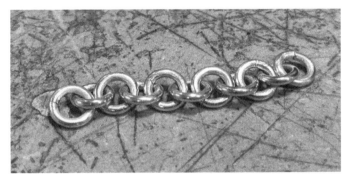

Links of the Chain
Matty
Metalwork

Dear *Ménière's Disease* (MD)
my somewhat constant companion,

We have been together since the late 1980s. We met in Perth, Australia, when I started falling. Deafness in both ears came about the same time.

The vertigo and nausea over many years often ruined my day. And then there was the very loud tinnitus. Up to 4 different sounds at the same time.

You did your best to limit, if not ruin, my work life. I will never forget the boss I had in Melbourne who loved to conduct walking meetings along busy CBD streets.

I finally got the better of you with my hearing when I was fitted with two Cochlear Implants. I wish I could have been allowed access earlier. It takes more effort to listen however, and I still cannot enjoy music unless the playing and singing is pitch perfect.

You have completely messed with me about my balance and posture. I now wear a back brace and use rolling walking aids inside and outside the house. I am grateful for the ongoing support from my partner Elisabeth. I am sure many times over the years I deserved a hit over the head. I am grateful for the NDIS (National Disability Insurance Scheme Australia), and my allied health workers.

I am very grateful for the research that is going on around the world, and the amazing technologies being applied to developing techniques that may help us. Maybe not in time for solutions for me, but in time we will beat you.

Sincerely,

Richard

MENIERE'S
RESEARCH
AUSTRALIA
AMBASSADOR

Ménière's disease from late 1980s
bilateral, cochlear implants

Dear *Ménière's,*

An invisible illness?

'It's all in your head,' they said.

They were spot on. It is all in my head, my inner ear to be exact—my vestibular system that affects every part of me.

The vertigo. The tinnitus. The deafness. The loss of balance.

Zero scars.

The fear, the anxiety, the depression, the suicidal thoughts.

Zero scars.

Losing my independence, my job, my social life. A prisoner in my own home, my own body. Helpless and alone.

Zero scars.

No cause, no cure. *Sorry.* It's a ghastly affliction. *Sorry.* The disease no doctor wants. *Sorry.* During active vertigo you are like a terminally ill patient six days from death ... *sorry.*

But the scars are written on my heart for every vertigo episode I've had, every tear dropped with loss of hearing and the tortuous tinnitus.

Bruises on my head, my legs, my arms, my hip, my back, my face, broken ankle, broken wrist, dislocated shoulder from drop attacks.

Too many scars inside and out. Psychological and physical.

An invisible illness?

Sure ... only because you see us when we are brave enough to venture out when we fake being well.

Simon

Ménière's disease since 2018

Dear Me,

Each morning when the *sun* greets me, and the *birdsong* welcomes the new day, I'm reminded that today is a *new day*, to leave yesterday in the past, and to *celebrate* my wins, no matter how small. I am not Ménière's disease, and Ménière's disease is not me. And, my *good days* far outnumber my bad days.

Love, Me

Without Warning

Here it comes.
Deep breaths. Find your focus.
Radiating tremors. Vision blurred.
For a brief moment, numbness.
Knowing the dark wave is about to consume you.
Deep breaths. Screaming inside,
"NO! Please God, not again. Not here. Not now."
White knuckles desperately trying to hold steady.
Sweat pours. Heart racing.
Every line bends. Every curve vibrates.
Close your eyes and it will find you.
Even in darkness you twist and turn.
Gut is writhing in distress.
So violent yet completely invisible for others to see.
Empathy is shared with whispers of doubt.
Solace too far to reach.
Independence lost.
Dignity robbed.
A bright future shadowed in fear.
In time, tremors dissipate and vision clears.
The agony is rewarded with short lived joy.
Without haste, the crippling fear of the next one looms.

Micaela Grady

Written 9/8/2021
Ménière's disease since 2007, Vestibular Migraine: 2021

Tinnitus

Long after you're in bed
I hear noises in my head
Never the peace and quiet I desire
Sometimes drumming can be heard
Over the whistle of a bird
I know another ear I would hire
I toss and turn at night
Hoping that my hopeless plight
Will cease before another hour
But it never goes away
I think it's here to stay
Oh if only it was in my power
Then I would make it end
Before I go round the bend
Maybe then I'd finally be at peace
I know it's an unfortunate state
And I cannot help my hate
And pray some day for a release

Tanya

Ménière's disease since 2002

The Beginning But Certainly Not the End
Belinda Hind
Acrylic paint

This is how Ménière's makes me feel.
I'm standing in a beautiful field and the fog starts getting
darker everyday, everywhere I go, and starts making the
grass die, slow, but surely consuming me until I disappear.

Ménière's since 2012

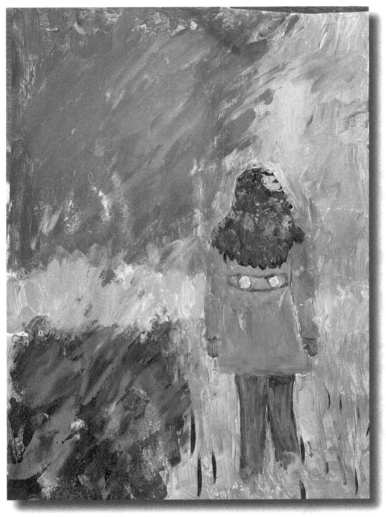

The Beginning But Certainly Not the End
Belinda Hind
Acrylic paint

Julieann Wallace

Dear *Ménière's,*

I hear you. Loud and clear in the incessant ring of tinnitus after you taking my hearing and leaving me deaf.

Cruel.

I see you. The world spinning around me at an uncontrollable speed in that terrifying violent vertigo for hours and hours that has me holding onto the floor for dear life.

Torture.

I feel you. With every step I take of imbalance, walking like a drunk, losing my balance, that nausea sitting in the pit of my stomach set off by movement around me, on TV, grocery shopping, shopping centres, the vehicles on the road.

The darkness of mind you bring.

And those drop attacks … bruising, dislocating, breaking bones. *Nasty.*

I know you. Playing with me like a puppet on a string. In control of my daily life directing what I can do and what I can't, with every single aspect of my life, even down to what I can eat.

You take pieces of me.

Shattering.

And I hear you and see you and feel you as I read those pleads of Menierians … those words of 'I can't live like this anymore. I want to end it …'

How dare you, Ménière's!

I remember that day in 1999, when Cat's husband posted on the Ménière's forum. A post about our dear Cat, who was so compassionate, full of support, wisdom and encouragement for others in our struggle with Ménière's disease. Everyone loved Cat. She posted every day. She cared for us every day.

And then she didn't.

I will never forget that day, that day that pierced me to my core. Those words from her husband - "Cat took her life two days ago …"

Shock. Disbelief. Grief.
I hate you Ménière's!
This letter is for those who have taken their lives because of you, Ménière's.

We remember them.
We honour them.
We fight for them.
They will not be forgotten.

And to those who struggle with thoughts of suicide, reach out. We've got this together. You are not alone. We see you.
Take my hand.
And I pray, Ménière's, that a cure for you will be found, or that a successful treatment will be created that will work for all of us. Then you can be laid to rest.
Meanwhile, my shield is up, deflecting all the symptoms and all the negatives you aim at me, Ménière's. I've cut the strings of your puppetry.

Julieann Wallace

Ménière's since 1995
Gentamicin 2004
Cochlear Implant 2020

Ménière's Tree
Julieann Wallace
Wire and stick

Somehow, working with wire, creating the spirals of
Ménière's vertigo gives me some sort of control of the
uncontrollable; trying to make sense of my world in a spin;
trying to create beauty out of the ugliness of vertigo. I'm
not sure I achieved the beauty aspect, but I did achieve a
sense of accomplishment.

The process of creating this art piece took enough
concentration to make me unaware of my loud never-
ending tinnitus, and I was amused each time the Ménière's
tree fell to the side with unbalance, like me. It proudly
sits on my mango-wood bookshelf, its harsh silver and
shininess in juxtaposition to the softness of my paperback
novels.

Ménière's since 1995

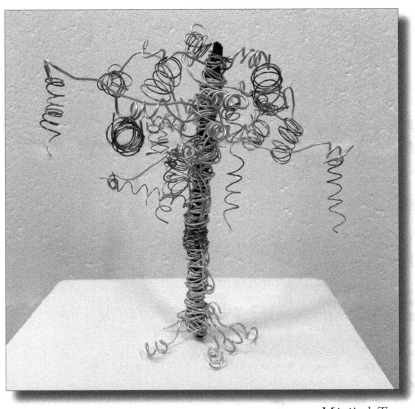

Ménière's Tree
Julieann Wallace
Wire and stick

Dear *Ménière's Disease,*

You have ruined my life.
You have taken away my freedom.
You are the reason I can't drive alone.
You are the reason I can't go for a walk.

You are the reason I'm scared to play with my kids outside.

You are the reason I'm scared to live my life.
You are the reason I spend most evenings in tears.
I fucking hate you, with every single fibre of my being.
You have completely, utterly and irrefutably destroyed my life.

You have taken my cheer.
You have taken my buzz.
You have taken my career.
You have taken my calm nature.

You have taken my life.

I wish I'd never met you.

Jye Bancroft

Ménière's disease since 2012

Dear *Ménière's Disease,*

Because of you ...

Last year my neighbour asked my girlfriend if we had separated because he hadn't seen me for months. **That hurt.**

Last year I couldn't make the flight that enabled me to say a proper goodbye to my dying Gran. **That hurt.**

Last year you took away my creative soul, and most of my hobbies until I could just stare at nothing but four walls 24/7. **That hurt.**

Last year I counted to 73. That was the amount of times I was well enough to leave my door. **That hurt.**

Last year my girlfriend spent time in a hospital bed and I couldn't visit and be by her side. **That hurt.**

Last year I had to learn how to walk properly again as I'd been stuck in bed for so long. **That hurt.**

Last year my mental health made me believe I was a worthless waste of space to myself and those around me. **That hurt.**

Last year so many times I was ready to give up, and leave behind my gift of life and those I love. **That hurt.**

This year, I'm trying so hard to take back parts of my life from your grasp, and next year I'll take back a little bit more. Your full control over me is dying away and my inner strength is slowly growing.

I hope that REALLY **HURTS YOU!**

Colin (That Monster Ménière's)

Diagnosed in 2019
Instagram: @that_monster_menieres

Ménière's Inverted
Patty Redeker
Photography

Before March 5, 2022, my life was organized. My days
were planned and everything was balanced. I enjoyed
photographing life's little details.

Christmas 2021, I received a gift; a crystal ball. When
holding the ball in front of the camera's lens, the image is
inverted.

Saturday, March 5th, I woke to the room spinning out of
control. One month later, I was diagnosed with Ménière's.
Now, I'm learning how to live life being inverted.

Ménière's since 2022

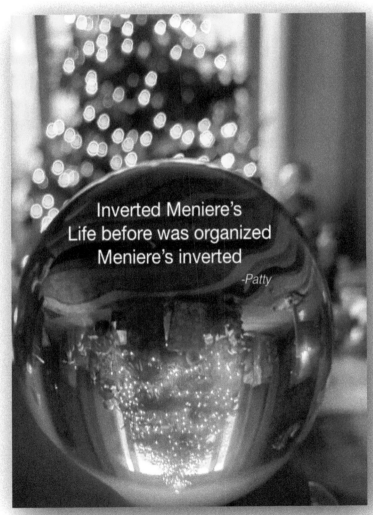

Inverted Meniere's
Life before was organized
Meniere's inverted

-Patty

Ménière's Inverted
Patty Redeker
Photography

Dear *MD*,

Every morning when my feet hit the floor, I want to hear you say, "Oh crap! She's up!" You have taken so much from me and I'm sure you feel some sense of pride. Only a bully picks and preys on the weak.

Well, I'm not even a bit apologetic when I say, "I'm not the one to be trifled with."

Just like any coward, you suckered punched me trying to get my children ready for school. No doubt, it was a hard hit, spinning the room so quickly. However, you never expected me to hold on, breathe, and then throw a roundhouse kick by still getting them off to school. Being angry with me, you knocked me to the floor as soon as I got home.

In those moments, I had time to think though. You've had me in this position before. I remember the days I use to give up and let you win.

I want you to know, those days are over.

The up-kick I threw knocked you back to your place of hell as I not only got up; I cleaned up breakfast while dizzy just to spite you.

You remind me of a nagging ex that just won't go away. It's so pathetic to be honest.

I know you saw my tears drop as I cried out to my God, "Just make it stop!"

You figured what a perfect time to try and finish me for the day. You threw a hard combo and my ears got loud, my head hurt, and I toppled a bit. Impressive—not!

I giggle now as I took all those hits, YET, I didn't get knocked out.

You see, you can knock me down but, you will never knock me out. It will be you who rings the bell, not me. With that, enjoy my throat punch that ended the fight.

My couch is so comfy and I will fight by resting. It's a beautiful day for a movie anyway, so thank you.

There are many things you will take and many things I can't control. The one thing I will never give you is my life. You can't have my positive mind or my beautiful soul. Sorry to disappoint your sorry a**.

On that note, please understand this is my ring, my fight, and I will always win. I'm just sitting in the corner of that ring getting cleaned up for the next round. See you soon.

Never truly yours,

Gina Marie (Kalitz)

Ménière's disease since 2001
Facebook: Ménière's and Vertigo Without Borders Founder & Admin
www.perfectly-broken.com

Pastel Indigo, 2023
Nicolle Cure
40 x 30 inches
Acrylic ink & paint, oil pastel & graphite on raw canvas

Over the years, I have created artworks portraying emotions and events that have profoundly impacted my life. For instance, my experience with Sudden Sensorineural Hearing Loss in 2017, which later became a Ménière's Syndrome diagnosis, has allowed me to use my voice and art to create awareness about "invisible" and debilitating vestibular disorders affecting hearing and balance.

Instead of hiding, I normalize my vestibular conditions as they have taught me valuable lessons. Through my art and advocacy work, I aim to inspire genuine conversations while providing a safe space for vestibular patients still learning to cope with debilitating symptoms. My goal is that Ménière's and other vestibular conditions are widely known so that there is more funding for research and finding a permanent cure.

There is a stigma around chronic physical and mental illnesses, the "BUT YOU DON'T LOOK SICK", which assumes that someone is healthy because they look "OK". Having to excuse ourselves from social activities or modify our lifestyle and interactions because of excruciating pain or "feeling off" is frustrating but also painful and isolating and filled with guilt for not being able to show up as our "full" selves.

However, despite being a vestibular patient for years, I've learned that this should not stop me from expressing myself through color, movement, and energetic and hopeful brushstrokes that narrate my story and relationship with sound in the visual form. Each painting has a bit of my story and Ménière's journey. My art is a collection of conversations, emotions, and experiences shared by vestibular patients who, like me, navigate this "dizzy" and daunting world in our beautifully flawed way, making us kinder and more resilient every day.

Ménière's disease since 2017
www.nicollecure.com/
www.instagram.com/nicollecure_art/

NICOLLE CURE
fine artist

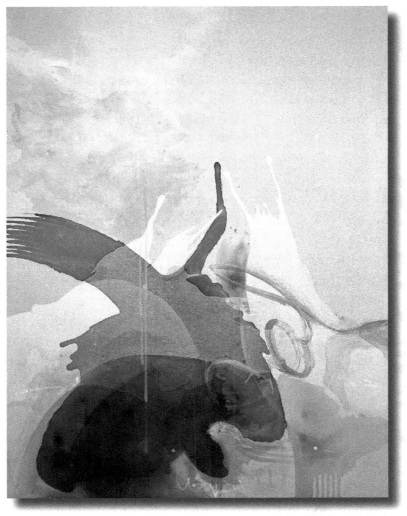

Pastel Indigo, 2023
Nicolle Cure
40 x 30 inches
Acrylic ink & paint, oil pastel & graphite on raw canvas

Dear *Ménière's Disease,*

Why did you choose me?
I wouldn't wish you, not even on a flea!
The world has spun and so have I,
Good thing there's always a floor nearby!
No more escalators, lifts, or chequered floors,
No more walking in the dark or battling spinning doors.
I've thrown up once and thrown up twice,
Being sick on a bus … it is not nice!
Woozy head and lights that flash. "Here we go again!"
Wobbly legs and 'sick bag' please, I never knew just when.
The hospital staff kept a bed for me, and IV fluids too!
They always said, "Hello again" and put me in front of the queue.
Doctor A said, "I don't know, go to Doctor B."
Doctor B said, "Nothing can be done."… "And here's my fee!"
Finally found a Doctor C who said weirdo things.
"Close your eyes and walk on the spot," but I walked around in rings.
"We'll have you right in no time." This doctor was the best.
Gave me back a life to live. There's now no time to rest.
Chinese food, and cheese and bacon, even chocolate left the table!
"What's left to eat?" my family cried. They now read every label.
It's under control now, but took many years,
Thanks to my mum who wiped away tears.
I'm back at work and a mum of two,
But, seriously Ménière's - who needs you???

Judes
Ménière's since 2005

Dear *Ménière's Disease,*

You came in like a wrecking ball to turn life on its head
So here's the way I conquered you and learnt to live instead
I had to grow in patience to cope with ups and downs
I learnt about resilience when falling to the ground
Learning to give in when my body needed rest
Knowing when to suck it up when feeling not the best
Fighting back the fear of a future looking bleak
Knowing I'd be feeling sick suddenly each week
My action plan was surgery to give me some relief
That action was my answer to turn a brand new leaf
I've lost some hearing on the way that's just the price to pay
So, Ménière's, I made it through, so kindly STAY AWAY!

Andrea Arnett

Ménière's for 49 years

The Beep Test
Julieann Wallace
Digital art on Procreate

I'm sitting in a soundproof room ready for my hearing
test. We Ménière's people like to call it the BEEP test. The
audiologist asks me, 'Your Ménière's started in which year?'
 'My left ear,' I answer.
 'Uh – huh. Which … *year* … did it start?' He repeats.
I burst out laughing at my mishearing. *Welcome to my life.*
He doesn't laugh like me. I'm guessing he has heard it all
before. I'm having my hearing tested for hearing loss after
all. Mishearing is nothing new to him.
 'It started in 1995,' I answer in a serious voice.
He sets me up with the earphones, beeper, gives me the
usual hearing test instructions then sits at his desk of
hearing test equipment. I cannot hear the beginning of
any beep at any time, but towards the finish of the testing,
at times I hear the end of the beep, *I think*, so I press the
button, *just in case.*

This art piece shows the loss of low frequency sounds,
which is a typical symptom of Ménière's, hence in the art
work there is no bass clef, just the treble clef. The splots of
paint represent me trying to hear the beeps in amongst my
tinnitus, with the dark blue splots representing the guessing
pressing of the button for the beep test.

Ménière's since 1995

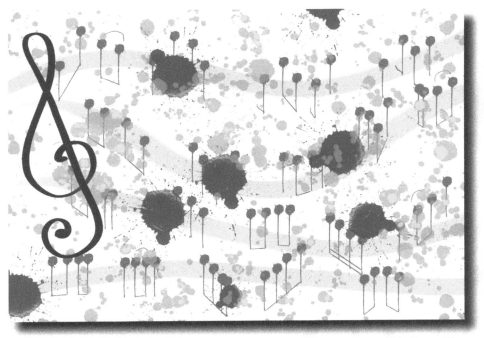

The Beep Test
Julieann Wallace
Digital art on Procreate

Dear *Ménière's Disease,*

It seems I have a new ability. One I didn't ask for.

I am now a walking human meteorologist and barometer, able to predict the weather.

Daily. Seasonally. Minute by minute.

In fact, my inner ear is an incredibly accurate weather predictor, more reliable than any daily weather forecast!

If there's a change coming, I'll know about it. I'll feel it, as the atmospheric pressure and temperature affects my symptoms, building up with the weather.

But ... I'd prefer not to have this ... *super* ... ability, making me feel like a bobblehead, a sober person walking like a drunk, the ramping up of my tinnitus, the anxiety of knowing that a vertigo attack is imminent. And then the violent vertigo attack that disables me totally.

I'd like to resign from this meteorologist position that I didn't apply for. Immediately!

Not your weather woman,

Skye

MD 28 years

Dear *Mama,*

I see you.
I see you wiping your wet eyes.
I see your tears dripping onto the pillow.
I see you wince at sounds that you say are too loud.
I see you, lying on your bed, staring at the wall, as still as a statue for a very long time. *Why can't you move?*
And when you are as still as a statue, I hear you vomiting loudly. It scares me. *When will you get better?*
I see you walking and nearly falling over.
I hear you crying in the shower.
I hear daddy crying, too.
It makes me sad.
I want to hold your hand.
Here, Mama. Have my magic wand. It will cure you. And then we can play together like we use to ... before you got sick with many ears.

From your favouritest-est daughter,

Lucy-Lou

P.S. I love you Mama, to the furtherest-est sparkliest star and back.
P.P.S. Please get better.

My Left Ear
Julieann Wallace
Watercolour & ink on paper

My left ear. Hearing loss. Vertigo. Ear fullness.
Screaming tinnitus. My tears pool when I think of the
horrendous Ménière's journey of my left ear.

The watercolours run down the page like my tears, the
purple heart trying but failing to hold in the emotions of
the ear in words of "I'm sorry I couldn't stop our loss of
hearing. Please forgive me."

Ménière's since 1995

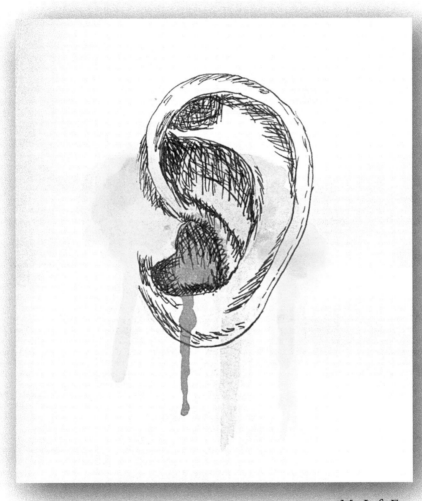

My Left Ear
Julieann Wallace
Watercolour & ink on paper

To *My One and Only,* Dear Left Ear,

I know you tried to keep our hearing. I know you tried so hard for so long. You battled against the Ménière's beast with reckless abandon. You fought hard against the inhumane, vicious, violent vertigo attacks. Together we struggled. Together we cried beyond a thousand tears filled with sadness, hope, asking for mercy, until we had no more tears to collect in our bottle of deep sadness, of stolen dreams, of a normal life to live.

'Why?' we asked. 'Why us? Why anybody?' But there were no answers.

Our world of hearing became muted, little by little. Stolen under stealth within vertigo attacks, leaving nothing but the impossibly incessant loud tinnitus as the flat line of hearing loss took hold – a confirmation of deafness – my brain desperately searching for some sort of hearing, but finding none, so instead, it made up its own sounds; a symphony of incessant annoying pitches, squeals, drones, beeps, cicadas, bees, a constant ocean wave that has broken, electrostatic buzzes, louder than anything I could hear with my good hearing ear.

Dear Left Ear, I acknowledge that you bravely and fiercely battled the Ménière's monster since 1995, with all of your might. An internal battle unseen with the oppressive, invisible, incurable illness. But it wore you down, until you had no more to give. And I thank you for your huge effort in fighting for us.

I heard it too, when the audiologist said in 2019, that we had little to no hearing, then called you a "dead" ear. My hand gently touched you and traced your outline after that blow to the heart.

Dead. It's such a final word. Complete. Absolute.

"It's not dead, just dormant!" I wanted to yell. But I didn't, as my heart cracked, the brutal sting of that word cutting so deeply I wanted to cry. Yet, it made me realise how much I loved you, even though we had been to the deepest, darkest pit of depression together, grappling for hope, desperately searching

for a cure for Ménière's disease so I could have you back with your miracle of hearing so profound and miraculous.

Ménière's disease. The cruel and unforgiving Ménière's disease. *It takes and never gives back...*

Dear Left Ear, we are rising against the Ménière's monster with a vengeance. No longer will we live our life in submission to the incurable illness. It may be incurable, but we can take a stand. We can take action. We are going to take control of our life. Our life. We won't let Ménière's decide our path for us and continue to beat us while we are down.

This is war!

Dear Left Ear, together, we will take back what is ours. We

will no longer have vertigo. We will be able to hear again. We will resuscitate your heart of hearing, and tinnitus will be drowned out with sounds of voices, music, and the harmonies of nature.

The battle line is drawn. Our swords unsheathed.

You are FINISHED!

Julieann

Ménière's since 1995
Gentamicin 2004
Cochlear Implant 2020
Instagram: @julieann_wallace_author
@myshadow_Ménières

An excerpt from:
It Will Change Your Life - a cochlear implant journey
by Julieann Wallace
- proceeds donated to Ménière's research

Waves of Suffering
Carol Esch
Quilt

One can imagine the swirls from the sounds and dizziness
one suffers from Ménière's disease. Trying to see clearly
while images swirl about and having small windows
of seeing clearly during waves of suffering has to be so
impossible.

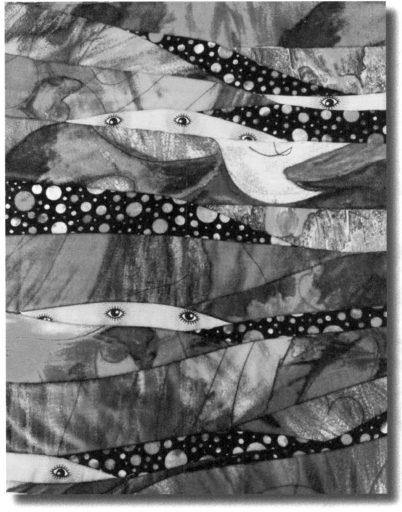

Waves of Suffering
Carol Esch
Quilt

Ménière's,

I'm scared of the dark. I know there's no monster under the bed, because it's in my fucking head.

You ever feel like life is finally working out? I have my own little family. I work hard. We're happy. But at any moment, the darkness can come.

In a panic attack they say to ground yourself, find something to focus on. With Ménière's, there is no perspective. Everything is falling. Everything is spinning. It can last hours. Days.

Can't walk. Can't work. Can't… *anything*.

I literally have to practise walking. Our neighbours probably think I'm an alcoholic …

I'm one of the lucky ones. I'm in remission.

I gave up all carbs: no rice, pasta, bread, noodles.

I gave up all sugar: no chocolate, ice-cream, soft drinks.

I gave up alcohol.

I started training and dropped 42kgs.

There are no cheat days, in case the darkness returns …

I was addicted to Valium. I was on brain-blocker medication. I couldn't work.

There are no cheat days.

I pay the price every day … it's just the cost of living.

But here's the thing. If you spend enough time in the darkness, you learn things.

1. *The darkness will lie to you.*

We all have darkness. You may not have Ménière's, but you have your own darkness. Depression, anxiety, addictions …

Your darkness will make you feel completely alone. Inadequate.

Different.

But if everyone has their own darkness, then doesn't that give us all something in common? Your darkness makes you just like everybody else. It's your membership to humanity.

So don't do it alone.

By embracing your darkness you will get the help you need. Even better, it will help others handle their darkness.

Your darkness connects you to me, and me to you.

2. *The greatest skill you can learn in life, is to dance in the darkness.* Darkness is real. It can come anytime.

If you are scared of the darkness, you'll be scared your whole life.

But if you can learn to find gratefulness in loss, joy in pain, and forgiveness in hurt, you will become greater than you ever thought possible.

The darkness is an opportunity.

It's the only place where real growth happens.

Being a good person when you're happy is not real. Kindness costs more when you're hurting. So it's worth more. Try being a good person when you're angry. Try smiling with a toothache.

Most importantly, the darkness is an opportunity to make the biggest difference.

When you face your darkness, when you smile despite it, and you dance inside it, you might just stumble into the light.

Don't wait for the darkness to go before you are happy.

Instead, *learn to dance in the darkness.*

Benjy

Ménière's: symptoms began 2018, diagnosed 2019
Youtube: https://www.youtube.com/@thebenjymann./featured
Facebook - Benjy Mann: https://www.facebook.com/profile.php?id=100085063291680

Dear Me,

One day, just like that ...

I'll re-discover my *light*.
I'll find my *strengths*.
I'll embrace my inner *warrior*.
I'll snatch my *power* back.

And the whole game will change.

Love,
Me

Ménière's... our journey ~

Once upon a time...

Life was good. Dreaming dreams. Love. Friends. Freedom. No fear of the unpredictable. Unstoppable. Happy. Family. Celebrations. Under the stars. Flying free in body and mind. Dreams to be lived. Fully living a life with so many possibilities. The world is my oyster. Peace. Joyous. Content. Delirious. Passion. Living on the edge. Run faster than I have ever done. Beautiful life. Success. Life is a crazy ride. So many options and pathways. Food. Music. Dancing. No limits. Optimistic. Travel. Sunrises. Riding the waves into the sunset.

Until the storm...

Of incurable disease. Depression. Frustration. Anger. Loss. *Why?* I want my old life back! Debilitating. Loneliness. Imprisoned inside a body that sends false perceptions. **It's all lies!** The world is spinning. **LIE!** Violently. Stop! Loss of hearing. Tinnitus so loud it's driving me insane. Fight. Please fight ... Never give up. Never ... *give up.* Fear imbued in each breath. Unpredictable. Existing, but not living. *I'm so, so, so tired.* Broken dreams. Shattered life. Courage. Tears. A million tears and counting. **Vertigo - how I hate you ... I HATE YOU!** Captive. Bound. Breathe. *I need a cure ...*

Hope ...

Yet there is hope ... for all things are possible. I will find me again in my messy, chaotic, difficult life. Patience. Good things are coming. Sound is more precious. Colours are more vibrant. Small things are the BIG things. Create new dreams. Celebrate when I can. Hold on to family and friends. Fuel my body with healthy food choices, healthy thoughts, and self-care. Forgive myself and others. Acceptance. Be kind to me. *Breathe* ... I'll get through this. Take my hand as I walk this path, this journey of courage to step through the fear. ...

Freed ...

Beyond thankful. Fearless. I found a treatment that works. I found a new and better me! Live my dreams. Make new dreams. Help others. Breath in the beauty of every day. Thank people who have helped me through the stormy seas. The world is my oyster with new opportunities. Life is more beautiful. Run again. Dance again. Learn something new. Excited for the future. Cherish friends and family. Embrace life, it's a gift, open it. *Love with all my heart.* Riding the waves into the sunrise and the sunset.
Never forget my journey ...

Julieann

Ménière's since 1995
Gentamicin 2004
Cochlear Implant 2020

Trapped
Julieann Wallace
Digital Art on Procreate

I drew this the day after having my second COVID vaccination in 2021, mandatory because I teach. After years of my head being clear, I suddenly had terrible balance, nausea, loud tinnitus, and what I call bobble head, and when I turned my head it felt like my body caught up to my turned head, three seconds later. I was terrified that I was going to have a vertigo attack after no vertigo since 2004 due to a gentamicin shot. In my mind, I immediately returned to those turbulent days of unpredictable vertigo where I would wait for weeks on end for the violent vertigo to hit, trapped in a sea of ticking time bombs. Thankfully it never did.

Recently, someone asked for permission to use my art for a tattoo. I'm looking forward to seeing how it looks.

Ménière's since 1995

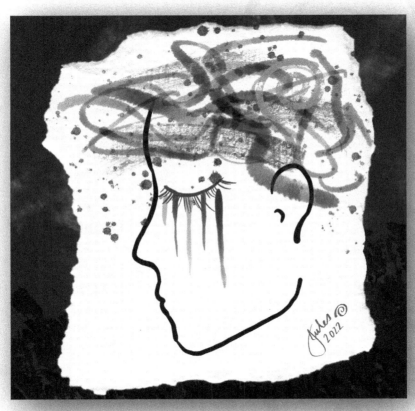

Trapped
Julieann Wallace
Digital Art on Procreate

To My Un-friend, *Tinnitus,*

SSSssssssssssssssssssssssssssssssssssss 'Pardon?' *What did my friend say?* Sss ssssssssssBBBBBBBbb bbbbbbbbbbbbbbbbbch ch ch ch ch ch ch ch ch ch ch ch ch ch ch *I can't hear the words over the impossibly loud tinnitus*ssssssssssssssssssss ssShshshshshshss sh sh sh sh sh sh sh sh sh sh sh sh sh sh sh sh sh four noises of tinnitus ... *What? I can't hear your words* ... I smile politely ... 'Sorry, can you say it again?' SSSSSSSSSSSSSSSBbbbbbbbbbbbbsssssssssssssssss sssssssch ch ch ch sh sh sh sssssssssss I squint and lean in closer. I turn my head and cup my ear. 'So sorry, can you say it again?' SSS SSSSSSSSSSSSSbbbbbbbbbbbbbbbbbbbbsh sh sh sh Ch ch ch ch Getting frustrated. Feeling embarrassed. Other people are looking at me. Anxiety is bubbling inside me. I want to run. **RUN** away. And cry. SSSSSHHHHHHHHHhhhhhhhhhhhhhhhhhhhsshs hsssssssshshhhhhhhhh *Deep breath.* 'Sorry, I have bad hearing. Can you say it just *one* more time, please?' *Ménière's! I HATE THAT YOU TOOK MY HEARING!* Person talks louder. I still can't hear the words. I look at other people for cues, my head swimming in movement. I smile and nod. People frown at me. Did my friend say something bad and I just smiled and nodded? *Again.* My friend looks confused. I'm feeling ashamed. ASHAMED! **Tinnitus, do you know what that feels like?** SssssssssssssssssssssssssssssssBBBB Bbbbbbbbbbbbbbbbbbbbbbbbbch ch ch ch ch sssssssssssssssssssssssss ss.

Isabel

Ménière's 28 years
Tinnitus 24/7 for 24 years
It never stopssssssss

Dear *Ménière's,*

Ten years ago, you took pieces of my health and placed them just out of reach like stars in the sky. My balance, my hearing, my joy for life hung just above me, taunting reminders of better days as they were slowly replaced by vertigo, tinnitus, ear pressure anxiety and depression.

On clear nights, it's as if I could reach up and steal a bit of them back for a time. I would be dizzy free, the constant ringing in my ear at a low, my head free from pain and with a boundless energy that I hadn't felt in months. I could go about my life, almost forgetting about my chronic illness. Days were almost normal as I worked, enjoyed dinner parties with friends, traveled beyond my home or relaxing on the couch watching a movie that I could actually hear.

Then, inevitably, the clouds would roll in and the days would again become dark.

Ménière's, although you deny me a life of relative consistency that is so easily taken for granted by others, I have made a vow to not just survive – but to thrive.

I no longer look up at my stars with sadness at what is lost, but with gratitude for what still remains. Each day is a gift, no matter how sunny or how grey. A gift you will never be able to take away.

Janine

Ménière's 10 years
janine@2ndchapterproductions.com
Website: https://www.2ndchapterproductions.com/
Facebook: https://www.facebook.com/2ndChapterProductions/
Instagram: https://www.instagram.com/2ndchapterprod/ @2ndchapterprod

Entering the Void
Judith Coombs
Pen, ink & watercolour

"Entering the Void" completed as an art piece 45 years ago for the Higher School Certificate.

Never did I expect it to be the epitome of what Ménière's looks like! It was created in pen and ink, and water colour, to show the delicacy of a butterfly entering the harsh reality of life. A beautiful life now swirling out of control into an empty place, the "unknown"…

Little did I know I would enter this myself!

Ménière's since 2005

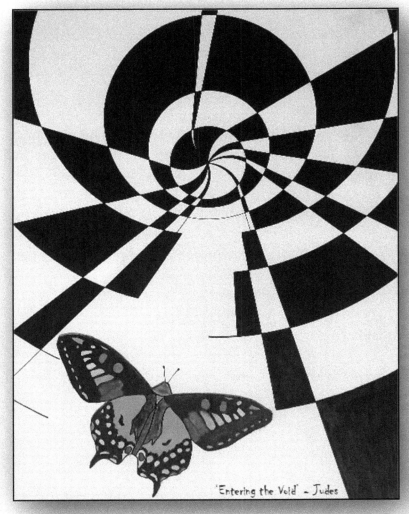

'Entering the Void' ~ Judes

Entering the Void
Judith Coombs
Pen, ink & watercolour

Hey *Ménière's* ...

You **blindsided** me! "If you say that you were blindsided by something, you mean that it surprised you in a negative way."* That's exactly what you did to my life, my career, and my dreams.

Before being diagnosed with bilateral Ménière's; I was pretty active and adventurous. I was always on my ten speed bike. It was not uncommon for me to ride fifty miles in one day, pack up my bike with camping gear, and go. I lived basically on my bike.

Blindsided.

As a teacher for 33 years, my professional days came to a halt in 2004 when the doctor ordered medical retirement at 49, due to the severity of bilateral Ménière's.

Blindsided.

No one plans for retirement at the age of 49. Lost my home. Lost my truck. Lost my car. My credit, gone.

Blindsided.

My love for the outdoors, camping, backpacking, and hiking, included part of the Appalachian Trail, The Manitou Islands, even a road trip to Montana, where I tried my hand at archeology. I thought "retirement career".

Blindsided.

My adventures now consist of sitting at my patio watching a gas fire pit flickering in the twilight, wildflower gardening, with my walker. Ménière's has taken many things away from me that I loved doing, but at the same time giving different ones than I expected to be doing at this stage of my life.

Blindsided.

Oh look! A Monarch Butterfly!
Go home, Ménière's. YOU'RE DRUNK!

Daniel

Ménière's disease since 1999
Facebook Ménière's Resources, Inc. Admin
https://menieresresourcesinc.org/

**Collins Dictionary*

Pink Floyd Has Vertigo
G. Lakin Rosier II
Pencil on paper

While discussing art with Julieann Wallace, she challenged me to incorporate vertigo into my art. The vestibular mascot is a Flamingo, I guess it's because it has such great balance. I was pondering that when I wondered how a flamingo would feel if it had vertigo. So I sketched it out. I didn't think a typical beach scene behind it would look right. Then I thought of my favorite painting, *Van Gogh's Starry Night* and how when my nystagmus is acting up, I can see the movement he depicted. The style seemed to be so much more fitting.

Ménière's since 2011

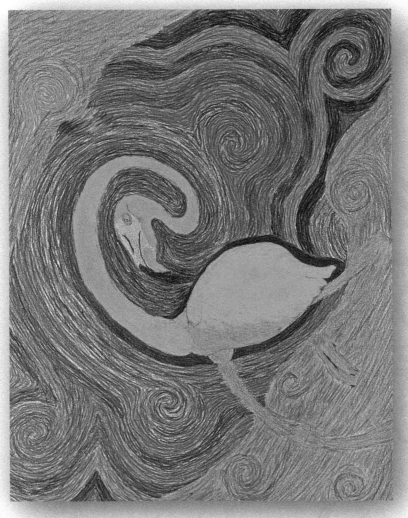

Pink Floyd Has Vertigo
G. Lakin Rosier II
Pencil on paper

Dear *Ménière's Disease,*

For everything you have taken from me, there are things you have also given me, so don't think you are the winner here.

You have given me the strength to stand in my truth, to listen to and trust myself and my body, even when the outside world doesn't understand.

I choose to forgive you, Ménière's for trying to take over my body, but know this, you no longer control me, I will live my best life despite your symptoms.

You may put me down from time to time - but you will NEVER WIN!

Wholeheartedly, *Heather Davies*

Ménière's symptoms for the past 7 years

VEDA
AMBASSADOR

Dear *Ménière's*,

Once upon a time, there was a very beautiful bird who loved to fly. She had everything a bird could ask for—a beautiful family, great job, and awesome friends.

Then one year she got migraines and her right wing was clipped. This was tough but she could still fly on most days. Then a few years went by and she got Ménière's and her left wing was clipped. Now this beautiful bird could no longer fly and she was devastated. She no longer was happy. Flying was what made her happy.

Then one day, she met the most beautiful bird she had ever seen. It was a peacock. This bird had the most beautiful features. The peacock went up to her and asked her why she was so sad. The little bird said her life was over because she could not fly.

The peacock responded: "Don't you still have your loving family, your great job, and your friends?"

The little bird responded, "Well, yes, but I can't fly any more."

The peacock responded, "So what! I can't fly and look at me!"

The little bird then thought about it, and thanked the peacock as she now looked at life differently…

Rebecca

Ménière's disease 9 years

Waiting for Blue Skies
Kathleen Ney
Mixed media

This artwork was first developed as a response to all the
bad news concerning the lack of climate action. I thought
it wasn't working and set it aside for several years. This past
spring and summer I had a flare up of Ménière's Disease
which didn't improve. I then was diagnosed with Vestibular
Migraine as an additional disorder since I have symptoms
of both. I didn't have the energy to do much artwork but,
when I felt well enough, went back to old drawings I had
set aside. This piece seemed to express how I was feeling
at the time waiting to find a treatment that would be
effective. To finish it, I added the collaged sky birds as some
hopeful elements, to remind myself to not give up hope.

If you'd like to purchase a print of this image, with a
percentage going to vestibular disorders research, you can
contact me at *www.kathleenney.com/giclees.*

Ménière's disease since 1999

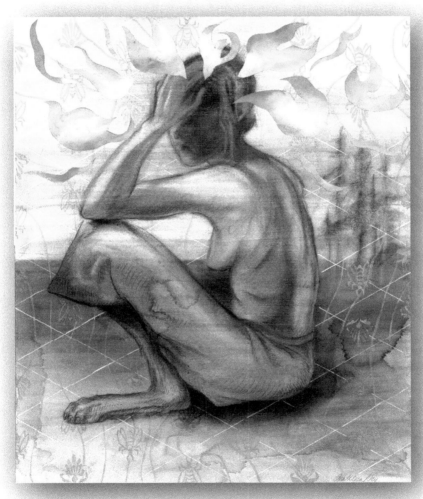

Waiting for Blue Skies
Kathleen Ney
Mixed media

Dear *Ménière's*,

As a child you tormented me, danced gleefully around my temporary deafness after a bad case of measles, smirked when I would suddenly throw up or spin out, laughed at our walk a mile, drive a mile on car trips. For years this continued.

You did not have a name then, my family and doctors had no idea what was wrong.

Then, driving home one day the world turned upside down rounding a corner.

I collapsed on the curb in front of my children and acquaintances. You were nasty, my whole body lost control, my ears screamed, I struggled in their toilet with diarrhoea, while vomiting constantly.

Admitted to the hospital by an elderly doctor for treatment and overnight observation. Same lovely, doctor visited next morning, sat a long time, asked my history and told me your name.

I finally had a name for you. Ménière's! He sadly told me there was no cure but that Stemetil tablets should be kept close always, he wrote me a script. I never saw him again, I never forgot what he said.

That was 1986. Subsequent doctors had no knowledge of, or interest in, Ménière's—you were persona non grata, a figment of my imagination.

And so it was another thirty years, very many of your mean nasty attacks and hospital trips later, before Prof Gibson formally confirmed that 1986 diagnosis in 2016.

Suffice to say Ménière's—ours has been a co-habiting relationship of the worst kind. You choose to drop in and out of my life at random times. You have loved to take control of my body, and like a sick voyeur you watch me purge helplessly. You take my hearing, my balance! You laugh out loud as I reach for something to steady myself. You push me to the brink of madness. You have heard me plead to die and end it all - and yet you have had no care. You come back, hold me hostage and torture me all over again. You almost succeeded in total control so that I would become recluse, a shadow of the person I once was, while systematically trying to destroy the person I could have been.

I know you think you can have me as your plaything anytime you want after all these years, that you can barge in and take me over whenever it suits you - but know this, I am still fighting you, I am getting stronger, I will not be your victim. I will survive you, and I will find myself again - stay in your world of darkness and meanness Ménière's - you can die in the depths of your cruelty, you will not win.

Floss

Ménière's since 1972

Dear *Ménière's* Disease,

You are hereby notified to **vacate** the inner ears of every human and animal on the planet of earth.

Leave NOW! Go directly to jail. Do not pass GO, do not collect $200.

Signed:

Ménière's Society of Earth

Date: MMXXIII

Ménière's,

I've decided I'm an athlete.

> *Athlete* noun - *a person who is trained or skilled*
> *in exercises, sports, or games requiring physical*
> *strength, agility, or stamina.*

I have a trainer—Ménière's. *I'm a Ménière's athlete!*

But unlike a well paid and famous sports athlete, I didn't chose this way of life. You, Ménière's, forced yourself upon me. *Vertigo. Tinnitus. Hearing loss.* That's just the tip of the iceberg. There's so much more as you perfectly know, Ménière's. And on top of it all, we fake being well, or normal, when we're with friends and at work, or socialising. Do you know how exhausting that is?

Ménière's, here's my athlete qualities, none which I have trained for but have acquired out of necessity to survive. You know what they are ...

Resilience *noun* - The capacity to withstand or to recover quickly from difficulties; toughness.

Me 1. Ménière's 0.

Flexibility *noun* - The ability to make changes or to deal with a situation that is changing.

Me 2. Ménière's 0.

Neural Plasticity *noun* - The ability of the brain to change its structure or function in response to internal and external constraints or goals.

Me 3. Ménière's 0.

Yes, Ménière's, I had to relearn to walk after having Gentamicin injected into my middle ear to destroy my balance cells to stop the torturous four hourly episodes of violent vertigo. Imagine having to make that decision, to kill off your balance cells?

Me 4. Ménière's 0.

And again, Ménière's, you took my hearing. I had to relearn to hear in my left ear when my cochlear implant was switched on.

Me 5. Ménière's 0.

Fortitude *noun* - Strength of mind that enables a person to encounter danger or bear pain or adversity with courage.

Me 6. Ménière's 0.

Courage *noun* - The ability to do something that you know is right or good, even though it is dangerous, frightening, or very difficult.

Me 7. Ménière's 0.

Strength *noun* - The quality or state of being strong : capacity for exertion or endurance.

Me 8. Ménière's 0.

Endurance *noun* - The act or an instance of enduring or suffering.

Me 9. Ménière's 0.

Patience *noun* - The capacity to accept or tolerate delay, problems, or suffering without becoming annoyed or anxious.

Me 10. Ménière's 0.

Compassion *noun* - Sympathetic consciousness of others' distress together with a desire to alleviate it.

Me 11. Ménière's 0.

Empathy *noun* - The action of understanding, being aware of, being sensitive to, and vicariously experiencing the feelings, thoughts, and experience of another of either the past or present without having the feelings, thoughts, and experience fully communicated in an objectively explicit manner.

Me 12. Ménière's 0.

Hope *noun* - desire accompanied by expectation of or belief in fulfillment.

Me 13. Ménière's 0.

Now that you have trained me, what is my sport of choice? Sword fighting, with the Ménière's antidote of research, pinned to the end of the very sharp point.

And my opponent? You, Ménière's! You're done!

Julieann

Ménière's athlete since 1995

Ménière's Attack
Michael Richardson
Watercolor

I did this artwork to communicate visually what cannot be communicated with words what's happening when a Ménière's attack happens to me. Doing an artwork like this is therapy for me – a way through the dark to the light at the end of the tunnel.

Ménière's since 2014

fineartamerica.com/profiles/7-michael-richardson
www.facebook.com/Micarikr?mibextid=LQQJ4d
Instagram: @theartistmjr
Google: Mica Rĭkr

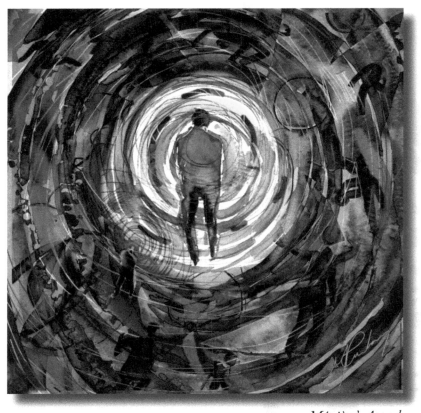

Ménière's Attack
Michael Richardson
Watercolor

Dear *Ménière's,*

You took away my hearing, my capacity to hold a job and my ability to do volunteer work for others. Because I could no longer work or continue service for others, I felt like I lost my identity. My hearing was so bad I felt like an observer in life; like I was not part of the world or even my family.

Then I got a cochlear implant. Now I feel like part of the world again, but more importantly, I feel like part of my family again. I found Ménière's disease support groups on Facebook. With the knowledge I gained from my doctors and through research, plus the life skills I already possessed, I discovered I could still serve others, by helping people learn to deal with you (Ménière's disease). In addition to the Facebook groups, a friend had the idea for a Ménière's Disease Zoom Support Group. Now I'm able to help Ménière's patients all over the world fight you (Ménière's disease).

Between the flare ups of symptoms, I found new ways to do the things I enjoy, and new hobbies. I have taken the opportunity to develop my talent as an artist. You're not beating me.

Sincerely, but not yours,

G. Lakin Rosier II

Ménière's disease since 2011
Cochlear Implant: 2017
Facebook: Ménière's Disease Zoom Support Group Admin

Dear *Ménière's,*

Remember me? The happy guy who used to smile and crack jokes, enjoying life. The guy you put a damper on when I was diagnosed years ago, struggling with vertigo, hearing loss and tinnitus.

Just to let you know, I refused to let you get the best of me. I try to live a life with a positive attitude, finding humor in the most difficult situations you throw at me.

You were there when I went to my friend's birthday party, remember? I was looking forward to that night, connecting with my friends again. Except, when the moment I arrived, I realized you were lingering with your nasty vertigo.

I had a hard time keeping my balance. But it wasn't bad enough to stop me from enjoying myself, yet. I wouldn't let you win.

As the night went on, I tried to have fun, despite my low level vertigo. Every time I accidentally stumbled into someone, I would laugh it off and make a joke. That's how I roll, right?

But then, something else happened, remember? I was dancing with a group of friends when the room started to spin more. I started to panic, but decided to go with it.

I started swaying to the music in a dizzying dance no one had seen before. I twirled and stumbled around the dance floor. I danced with a lampshade on my head, and everyone started to copy my "Ménière's Dance Moves". A whole dance floor of dizzy dancers! I had won!

Dizzy Dave
Ménière's 7 years

Nine Days and Counting
Colin (That Monster Ménière's)
Photography

Stuck in my prison amongst both darkness and light,
One moment it's morning and the next it's now night.
Waiting for freedom with the sun on my face,
Breaking and then building in my dizzy personal space.

Colin (That Monster Ménière's) Diagnosed 2019
Instagram: @that_monster_menieres

Nine Days and Counting
Colin (That Monster Ménière's)
Photography

Dear *Ménière's Disease*,

I just want to say, FUCK YOU!

You have robbed me of so much in the 22 years you have been around.

You have taken me away from so many important events with my loved ones.

You have chewed up myself confidence my sense of adventure and independence then you spit out a spinning, dizzy, tired, scared, anxiety-riddled shell of my former self.

You hold me hostage EVERY. FUCKING. DAY. And I despise you! Even with all of that I refuse to let you make me bitter.

With everything you have ripped away from me you have also helped me.

I should also say *Thank You*. Thank you for forcing me to slow down, forcing me to really take stock of what I value in my life.

Thank you for making me put nutrition and health a top priority.

Thank you for forcing me to learn how to advocate for myself.

Thank you for opening me up to trust myself and follow my intuition.

Thank you for helping me realize that making myself a priority is not selfish.

Thank you for shining a light on the real ride or die people in my life.

Thank you for guiding me to find people like me who know what this hell I endure daily is really like.

Thank you for making me a warrior, but still FUCK YOU for making me fight this battle.

Respectfully, a warrior kicking your ass daily for 22 plus years,

Amanda J.

Ménière's diagnosed: 2001
Facebook: www.facebook.com/mizshorty2u
Instagram: mizshorty2u/Amanda Jew

Dear *Ménière's*,

My life wasn't exactly perfect, nor was it easy, but it was pretty simple for me. You know, I was getting fitter and healthier than I had been in a very long time. I was walking longer distances and doing it every day!

Not sure if you had realised before visiting me that I had a brain aneurysm when I was just 21! Yes, that young, crazy right?! After my surgery I suffered a stroke and had to learn how to walk again and use the left side of my body. That was a pain, but your visit was even more painful.

Now at first I thought maybe it wasn't really you at all but just a virus of some sort, and I would feel better with antibiotics in no time. *Wishful thinking ...*

But no, you had just left a little taste of what was yet to come.

You gave me spinning. Lots of spinning inside my head like I was on a really rocky boat which in turn made me very nauseous!

Then my hearing went. Everyone was whispering but muffled but just one ear? Why just one? Strange, did you now like that ear?

Oh, then I couldn't walk that well again like I was walking on a boat, and much to your amusement, I'm sure I purchased my first walking stick ... *eye roll.*

But you know what?! I am taking care of me and the medicine I'm taking pushes you further and further away ... *for now.*

You may have taken my hearing and some of my friends, but you have and never will take my fighting spirit to rid you from my life FOREVER.

Not your friend,
Belinda

Ménière's disease since 2012

Help Us
Julie White
Digital

After speaking to my fellow Ménière's disease warriors,
we came up with a list of words which best described our
day to day living. I converted the information to this art
piece.

Ménière's for 25 years
Facebook: The Invisibles

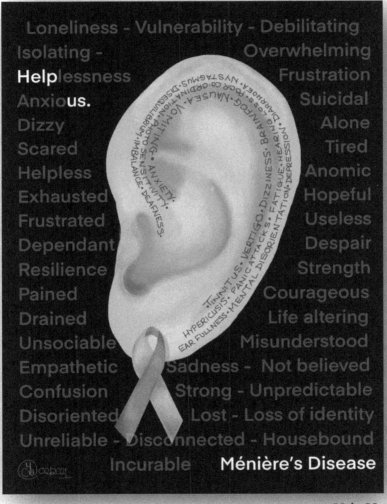

Loneliness - Vulnerability - Debilitating
Isolating - Overwhelming
Helplessness Frustration
Anxio**us.** Suicidal
Dizzy Alone
Scared Tired
Helpless Anomic
Exhausted Hopeful
Frustrated Useless
Dependant Despair
Resilience Strength
Pained Courageous
Drained Life altering
Unsociable Misunderstood
Empathetic Sadness - Not believed
Confusion Strong - Unpredictable
Disoriented Lost - Loss of identity
Unreliable - Disconnected - Housebound
 Incurable **Ménière's Disease**

TINNITUS· VERTIGO· DIZZINESS· BRAIN FOG· NAUSEA· VOMITING· ANXIETY· HYPERCUSIS· PANIC ATTACKS· FATIGUE· HEARING LOSS· POOR CO-ORDINATION· DISEQUILIBRIUM· DIARRHOEA· NYSTAGMUS· EAR FULLNESS· MENTAL DISORIENTATION· DEPRESSION· PAIN· WITH· IMBALANCE· DEAFNESS.

Help Us
Julie White
Digital

Dear *Ménière's,*

Fatigue
noun: fatigue; plural noun: fatigues
1. extreme tiredness resulting from mental or physical
exertion or illness.

That's you, Ménière's. Fatigue from violent vertigo. Fatigue
from trying to hear through the deafness, through the loud tinnitus;
trying not to focus on the hyperacusis. Fatigue from trying to work
out the direction of sound. Fatigue from concentrating on my
balance. Fatigue from the fatigue.

And then there's the *new* fatigue.

Remember my Cochlear Implant journey, Ménière's, when you
followed me around like a sulking child because I was taking back
my hearing from you. On the 9th of January, 2020, my Cochlear
Implant was "activated". My world of deafness, including the five
roaring noises of tinnitus changed. I could hear again for the first
time in 15 years!

My cochlear audiologist warned, 'You will have mental fatigue
from hearing again with your left cochlear.'

Yeah nah, I thought. I've had the repugnant, revolting, repulsive
Ménière's disease for 25 years now, three children and a teaching
workload. I know exactly what mental and physical fatigue is like.
The simple act of hearing again will leave me fatigued. I doubt it!

Yeah Nah. Australian slang for no.

After my CI was switched on and fine-tuned, I entered the
outside world. *Reality*. I was no longer safe and comfortable in the
confines of the quiet audiologist's office, where reassuring smiles,
encouragement and support, wrap me like a warm blanket on a
freezing winter's night.

My eyes widened. It's so NOISY! I hear EVERYTHING! But
not the sounds of normal hearing, but of cochlear implant hearing,
newly activated: chipmunk voices, robotic representations of every
sound my 22 electrodes can feed into my auditory nerve. I am told
that what I hear now, is not what I will hear as I continue to attend
"mapping" sessions. Sounds will become more "normal-ish", like what

I hear with my right ear.

After 10 hours of wearing my processor, I am fatigued. I feel like a flat battery.

My cochlear audiologist said, 'It's like you're a baby again. You hear absolutely everything. For your left hearing centre in your brain, every noise is new, and it's working hard to work out whether to file the sound as an important sound, or background sound, that it doesn't have to pay attention to. And the two hemispheres of your brain are not working together, yet. But they will.'

She continued: 'When you lost your hearing 15 years ago, your brain re-used that area for something else, and now that it is stimulated again with hearing, your brain is madly reorganising what parts of your brain are used for what. It is also accessing your auditory memories to match up to what you are hearing now.'

The brain wastes nothing…

The rain is falling on our tin roof when I get home. I step off the veranda with my umbrella, and close my eyes. A tear slips down my cheek. I can hear droplets of water battering the umbrella with two ears. For the first time in 15 years. It's a big deal. I never thought I would hear the world around me again in my left ear, except for the five torturing sounds of loud, relentless tinnitus – louder than any rock concert or loud party I had attended – a symptom of the abhorrent Ménière's disease.

The rain is in 'surround sound'. It's surreal. I twirl, slowly, without losing my balance. My own type of rain-dance, keeping my cochlear implant processor dry.

Bliss. Happiness. Beyond thankful.

The gift of hearing. Thank you can never be enough to *Professor Graeme Clark AC*, the inventor of the multi-channel cochlear implant. My heart now smiles every day, thanks to my new hearing. Three years on from my CI, it is easy to forget I am deaf in my MD ear. Mind blowing technology!

Julieann

Ménière's since 1995 Cochlear Implant 2020

Unfinished Symphony in Blue
Julieann Wallace
Watercolour & ink

Art is a story by the artist, except, you bring your own story
and life experiences to the art, creating your own story in it
as well.

This art piece symbolises the loss of hearing due to
Ménière's disease. It's a journey of grief and anger and
sorrow. Of having something so precious taken away.

Weirdly, when I finished drying the final large blob in the
3rd frame with a hair dryer because I had limited time to
finish it for an art exhibition, I looked closer and saw a
monster. An ugly one at that! I laughed so loudly! It was
unplanned. It just appeared in the artwork. My shadow, the
Ménière's Monster. A horror story. Apt.

Ménière's: 28 years

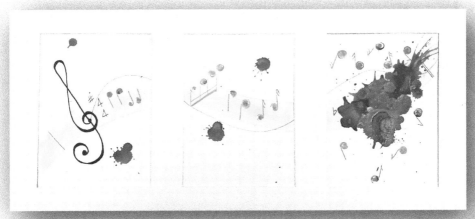

Unfinished Symphony in Blue
Julieann Wallace
Watercolour & ink

Dear *Ménière's,*

I have always loved the artwork of *Vincent van Gogh* and was so intrigued as to why he cut one of his ears. It would take me years later to understand why a person could be desperate enough to do this.

I first met you in April of 2014, though I would not know your name until later. You stopped in to say 'Hi' one day when I was staying after school with my high school seniors.

You hit me with a high pitch sound in my right ear that was so intense I thought my brain was going to explode.

How dare you choose to interrupt me as a teacher. This has always been my passion and you didn't care.

It took me three years of testing, seeing specialists, and suffering from loud tinnitus, drop attacks and vertigo attacks before you had a name.

I was then wearing one hearing aid because that day you stopped in to say 'Hi', you took most of my hearing with you.

I was barely surviving as a teacher and was petrified to drive.

You forgot to leave a warning sign with me that states "drop attacks and vertigo attacks can happen at any time without warning" ...

Not to mention "loud high pitch tinnitus will forever make you wish for silence."

This would have been helpful for me, as twice, I was driving when these took place and even with two hearing aids, listening was a chore.

I was very lucky to find a great ENT and Neurologist who taught me how to manage life with your vertigo and migraines.

In October of 2017, my ENT doctor sent you away on vacation for a little bit. I received my first transtympanic labyrinthotomy (gentamicin injection).

Although I couldn't teach that year and I underwent many months of therapy, I was able to return to teaching the following year and regain my independence.

You continue to be very persistent to stay in my life, as I am now bilateral.

As I sit here recovering from my second procedure, I am done crying over you! I can feel the gentamicin toxin just eating away at you and I have learned that while my life will never be the same, I will not let you bring me down.

I will return to teaching next year and continue to do what I do best.

I will also educate those who may not know you as well as I do and let them know there is a way to manage you and keep you silent!

Rebecca

Ménière's: 9 years
Bilateral

Isolation - a self-portrait
Steven Schwier
Acrylic paint on canvas

My art is a window into my soul. Although dark, demented and disturbing, it's the real me. If I didn't feel the way I do, I wouldn't paint the way I do. My soul on canvas I guess.

This is me, isolated by Ménière's disease.
The brushstroke does not lie!

Ménière's since 2012

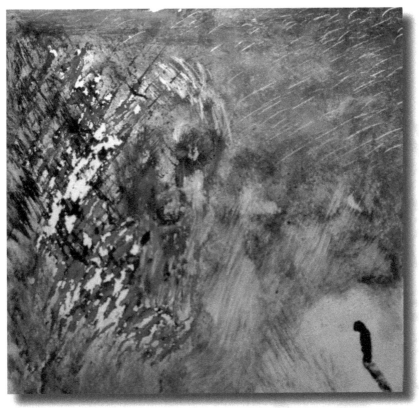

Isolation - a self-portrait
Steven Schwier
Acrylic paint on canvas

Dear Otolaryngologist (ENT),

I walked into your office with a blocked left ear, like I had been swimming, except, I hadn't. You frowned. You peered inside my ear canals. Tested my hearing with a tuning fork. You made me stand and walk on the spot with my hands out in front of me and my eyes closed, and asked a thousand questions. I walked out of your office with paperwork for a blood test and CT Scan, looking for a brain tumour. The receptionist politely looked beyond my tears.

The results were clear and you said, 'Let's wait and see what other symptoms you get.'

Then came the vertigo, the hearing loss, the tinnitus.

You sprang into action, and sent me for more definitive Ménière's testing, and asked me to try different medications to stop the symptoms.

You carefully read every research paper I presented to you in my forever search for a cure, and supported me in my quest to try what I had found, even though you knew some of the treatments would make no difference.

When non-invasive treatments didn't work, you took me to the next step. A grommet, to no avail. Then gentamicin. *Success.*

Thank you for walking beside me in my Ménière's journey. Thank you for your experience, compassion and wisdom. Thank you for listening to my words and understanding my tears of sadness. Thank you for acknowledging my husband and thanking him for not leaving me. Thank you for the recommendation to a wonderful cochlear implant surgeon so I could hear again.

Thank you. With a heart full of gratitude,

Lily

Ménière's disease since 2000

Ménière's,

You think you are a giant, standing over me.

Though I'm afflicted, I am not crushed.
Though I'm anguished, I won't give up.
Though I've been cast down, I have not been broken.

I will rise taller, stronger and more determined than you.

Now you are under my feet, giant.
In the battle, you've lost!
I have broken your chains, they've fallen off.
And I will arise, standing over you.
Now you're under my feet, giant!

I am a survivor. A warrior.
Outwit.
Outlast.
Outplay.

Never yours,
Claudia
Ménière's disease since 2020

Vertigo Fear
Julieann Wallace - stolen art
Lino carving

I have the great privilege of teaching Secondary Art.
Spending time with creative teenagers is fascinating
and inspiring. Delving into their deepest thoughts and
ponderings and how they see themselves and the world
is totally insightful, and seeing how their minds work is
nothing short of breathtaking. Their art is an outpouring of
their loves, fears, hopes and dreams.

One day, a 16 year old student was carving some lino
for 'fun'. As I watched it evolve, I was awestruck by how
accurately it portrayed both a fear of vertigo *and* a vertigo
attack. I couldn't help but see the resemblance to the art
style of *Vincent van Gogh*. Apt. She discarded her art at the
end of the lesson. It was nothing but just something to do
in her free art time. I asked her if she was going to keep her
lino piece or do some prints with it, and she said no. At
the end of the year, this lino piece sat amongst the art to be
tossed out. So I claimed it. A stolen moment in time that
spoke volumes to me and my Ménière's.

Ménière's since 1995

Vertigo Fear
Julieann Wallace - stolen art
Lino carving

YOU, *Ménière's!*

How dare you! How dare you attack my wife!
How dare you take away her passion of teaching, her career.
How dare you take away her love of playing sport.
How dare you take her ability to listen to, and play music.
How dare you make the light fade in her eyes. Yes, the *light* ...
How dare you take her hearing, her balance, her confidence so
that she became a shadow of herself.
How dare you make her spin so violently for four hours at a
time, unable to move, staring at the wall for the entire time,
violently vomiting until only froth was brought up, her weight
melting away so her bones stuck out.
Do you know what it is like to watch your wife suffer and not be
able to do anything to help her? Do you know?
How dare you put her through a dark, dark depression where I
thought I was going to lose her ...
How dare you take away the enjoyment of raising our children,
every day filled with fear of a vertigo attack.
How dare you make her cry ... no ... sob so heavily like the dark
night of the soul. There was nothing I could do to ease her
pain, but sob with her.
How dare ... you, make her life a ... misery!
How dare you stop me from being able to make my wife better.
I tried. So hard. And I will never give up.
How dare you do this to anyone ...
How. Dare. You!
Did you count my tears too?

From an angry *husband*
- his heart breaking for the love of his life

Dear **monster**,

You are ...

AKIN TO SHIT on a shoe trodden through a carpeted home,
A 6 HOUR LONG podcast with a voice so monotone.
Like riding a bike with a constantly falling off chain,
A summer garden party that is RUINED BY THE RAIN.
The spilt glass of water that calculatedly covers one's crotch,
Like paying for Netflix then discovering there's barely anything
 good to watch.
The SOGGY WET SOCK and also the HOLE IN THE BOOT,
Like discovering HALF A WORM after biting into some fruit.
A SALT AND VINEGAR CHIP on a fresh paper cut thumb,
The APPROACHING BEAST IN THOSE NIGHTMARES
 where we are unable to run.
Truth is, you are SO MUCH WORSE than all these examples
 by a mile,
This is me keeping it light, and trying my damn hardest to
 CREATE A SMILE.

Colin (That Monster Ménière's)
Diagnosed, 2019
Instagram: @that_monster_menieres

Dear Me,

Forgive others when they don't understand my life with Ménière's disease - the vertigo, the tinnitus, the hearing loss, the anxiety, the unpredictability of my social life, the depression, the grief, the PTSD.

Forgive myself as well.

Love, Me

Imagine being me

Come take my hand I want you to see
I want you to imagine that you are me
Humour me if you will
To live in a world that is never still
You wake each day praying it's not worse
You see that's the beauty of this curse
No day is one and the same
There are no winners in this cruel game
You see even when still I feel some kind of motion
Imagine a ship on a stormy ocean
The floor should be solid but some days it's moving
Like being in a car that is always cruising
Even a light can trigger me off
You would chop off your arm to make it stop
You feel yourself sweating as the next ride begins
Being able to stumble to bed, you take these small wins
You lie down to rest your spinning head
Praying you don't fall off the bed
Sweating and shaking you have been here before
You want it to be over but it's giving you more
All you can do is lie there and pray
Please God, let this nightmare be over today

You have to sit up it's the only way to sleep
But you won't rest easy it's never to deep
You see this trip it came for free
I didn't want to get on, but it wanted me
They said it won't kill me just feels like it might
Everyday is exhausting putting up this fight
The fun doesn't end there your ears will buzz and hiss
You see it's the silence that I truly miss
Then sometimes someone is squeezing your head
It's not nice to say I would rather be dead
The lights in my eyes put on a show
I can't run away there's nowhere to go
I'm trapped here so come take my hand
Let my lead you out of Alice and Wonderland
You can get off but I always stay
I want to get off I pray for that day
I hope that this poem has made you see
What each day is like living as me
So when you see me and I look far away
Know that I could be having a bad day
There's invisible illness that you can't see
But stay by my side and be glad you aren't me.

Donna

Ménière's since 2009

All at once, the Endolymph
Allison Maslow
Acrylic & ink on canvas

This is my interpretation of what happens when the
Endolymph fluid in the inner ear builds up and causes the
cascade of symptoms that we with Ménière's experience
and feel. I chose to represent this physical process in the
form of a wave in a storm. It is a storm that can't be seen
by most, but it is one well-known to us.

As I painted I was dizzy and moving in my head, and
this feeling was manifested in the way I painted this. The
movement, the rawness, and the texture were important for
me to portray the physical feeling as I was living it.

Ménière's since 2022

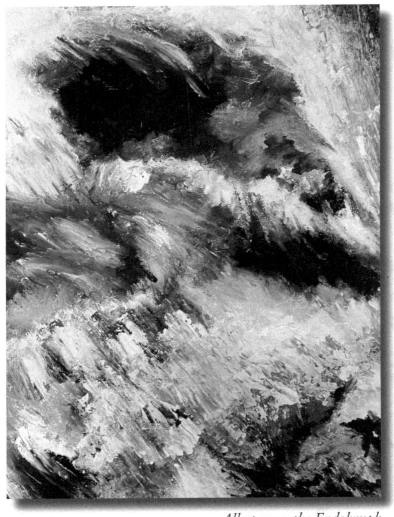

All at once, the Endolymph
Allison Maslow
Acrylic & ink on canvas

If I only had **tinnitus**,
I think that I could cope.

If I just had the **fullness in my ear**,
I really wouldn't mope.

If **my balance** was just a bit impaired,
I'd grin and I could bear it.

If I were only **losing some hearing**,
I think that I could spare it.

If once or twice I **dropped to the floor**,
it wouldn't be the worst.

I wouldn't cry if the only symptom
was **feeling my ear will burst**.

If **brain fog** happened once in a while,
I'd go about my day and smile.

If **certain noises made me cringe**
and left me shaking and retching,
I honestly would be okay, and I would not be kvetching.

It's having all of these each day
that taxes my good mood.

And so at times it's just too much ...
and sorry, but I brood.

Helene Fryd Wenger

Dear *Ménière's*,

You stole so much from me.

My balance which I had to work hard to gain back. It wasn't fun wobbling down the street looking like I'd been day drinking!

And as if that wasn't bad enough! To top it off you reached in and snatched my hearing! I hope you had a good laugh at my expense. Especially the time I was out with a friend having coffee (now decaf thanks to you) in a crowded cafe. My friend, who was sitting on my right side, the deaf side, spoke to me, and I looked at her and said in a loud voice, **"What do you mean you just had casual sex!"** (I was shocked.)

Most people in the cafe turned to look. Obviously the word sex got their interest.

My friend, in a horrified voice said: **"I said I just bought a new dress!"**

Thank goodness I didn't add that it only cost me $50!

Well, I must admit we laughed until mascara ran down our faces.

After telling that story to my audiologist, who couldn't keep a straight face as he said, **"Maybe it's time you said yes to a hearing aid."**

I had been resisting until then.

I've learnt to live with you, but to be honest, I wish you would just pack your bags and go!

Irene Curtis

Ménière's diagnosed: 2019 but symptoms for a long time before

Sound & Fury
Allison Maslow
Acrylic & ink on Yupo paper

From the moment I wake up until the moment I go to sleep my ears are a cacophony of multiple tones, short, long, sharp, soft, and everything in between. This piece is an interpretation of living with this cruel daily reminder of sound while losing sound altogether as our hearing deteriorates. I chose to represent this experience abstractly because it is an experience that can not be easily articulated or rendered. It is in many ways just like trying to explain Ménière's disease to someone who doesn't live with it.

Ménière's since 2022

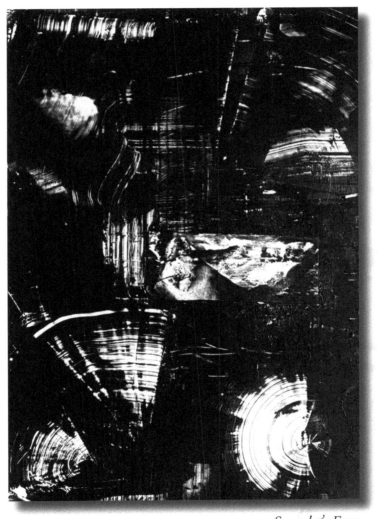

Sound & Fury
Allison Maslow
Acrylic & ink on Yupo paper

Dear *Ménière's Disease,*

I'm so scared:

Of vertigo for hours and hours and hours.

Of vomiting violently until I am dehydrated. Of hearing loss. Of tinnitus. Of brain fog. Of my ear feeling like it is blocked.

Of leaving the house. Of walking like a drunk. Of mishearing people. Of missing out on life. Of being uninvited. Of being rejected. Of not being able to participate in life.

Of not getting disability payment because the government doesn't understand what I go through. Every. Single. Day.

Of not hearing the voices of my children. Of not being able to play with my children.

Of being left out.

Of anxiety and panic attacks.

Of missing important occasions.

Of the loud tinnitus that never stops.

Of people looking at me with pity.

Of people who say, "everyone gets dizzy dear". They don't understand the violent vertigo.

Of friends leaving me. Of whispers behind my back.

Of being told I am faking my symptoms.

Of drop attacks that will break my bones, bruise me or give me concussion.

Of losing my identity. Of losing my job.

Of feeling like a nothing.

Of being invisible.

Of being in that dark, dark place saturated in deep sadness.

Of my husband leaving because Ménière's makes life too hard.

Ménière's, *just leave …*

Zoey
Ménière's disease since 2014

Dear *Ménière's Disease,*

I'm ready:

To fight the vertigo. To fight my hearing loss. To accept the loud tinnitus that never stops, and tune out of it. To work with the brain fog. To ignore the feeling of my ear being blocked. To keep a Ménière's journal to find my triggers.

To venture out the house, with courage. To laugh at myself when my balance is off. To learn to ask people to repeat themselves and lipread what they say. To participate in life on days when I can. To forgive.

To try to live with no fear of Ménière's. To invite people back into my life. To be thankful for friends who stay. To choose which life activities I can participate in that will not exacerbate my symptoms. To fight for my disability payment and help the government understand what I live with every single day, for me and others.

To treasure each day I can hear the voices of my children. To enjoy every moment when I am able to play with my children and not dwell on the days when I can't. To be okay with me and not compare myself to others. To practise control of anxiety and panic attacks. To apologise politely when I can't attend important occasions, without guilt.

To understand that people who look at me with pity are caring in the only way they can. To explain Ménière's vertigo to people who say "everyone gets 'dizzy dear'", so they truly understand that vertigo is the room spinning, incapacitating me. It's life changing. To have a plan for when I have vertigo or a drop attack—what next, who will help?

To create my new identity with gratitude. To find a job that works for me, or create my own job. To feel like a Ménière's warrior. To seek help out of that dark place and look for things I love and am thankful for. To thank family and friends for everything they do for me.

Ménière's, *I've won!*

Zoey
Ménière's disease since 2014

A Sacrifice to the Alter of Ménière's
Steven Schwier
Photography

Ménière's, you've taken so much from me, taking my
ability to enjoy music was the biggest blow to what allows
me to live and love life. I will fight with every fiber to not
give you everything you want. I'm left with a shell of my
former self, but you will not win. I will play and I will
continue to love the things I love. So here's a big middle
finger to your passion to steal from me. My hearing and
abilities are tainted by your interference, yet *I will fight on.*

Ménière's since 2012

A Sacrifice to the Alter of Ménière's
Steven Schwier
Photography

Jules

Dear *Mum* and *Dad*,

Thank you. Thank you for believing me when I told you of my symptoms. I look back and wonder how hard it must have been to watch your own child suffering, and not being able to do anything to help. But help you did.

Thank you for always dropping everything and running to my aid when I was hit with a long winded vertigo attack that grounded me, unable to move for hours and hours at a time.

Thank you for taking care of my precious children when I couldn't. So many times. So, so many times. I'm beyond thankful that you kept them busy and happy and that they don't have any memory of how sick I was when vertigo had me pinned to the deep darkness, and I would cry, "I can't do this anymore, I can't do this anymore!" over and over and over again, my prayers written in my tears.

Thank you for paying for medication when I couldn't afford it because I couldn't work. Thank you for paying for the Acyclovir antiviral because I couldn't pay for it.

Thank you for buying me that Sony Walkman and Tomatis Effect Sound Therapy tapes. Thank you for paying for the many sessions of acupuncture. I know you were desperate to find a cure as much as me.

Thank you for crying with me. It hurt that I had caused you so much pain, but as a parent, I understand it perfectly.

Thank you for staying with my kids while I was taken to the emergency department at hospital.

Thank you for your relentless search for a cure. And thank you for your prayers. They were answered in the form of gentamicin, that stopped my vertigo and gave me my life back.

I'm so blessed that you are my mum and dad.

Love you forever and a day,

Jules

Ménière's disease since 1995

113

Ménière's Maestro

Your song swishes softly
Surprise
Cymbals and trumpet
Wonder
A flute sings at middle C
Curious
What are the lyrics?
Incomprehensible
Time to move
Dance
Vision sways and swirls
Pirouettes
Spinning and whirling
Relentless
The world falls away
Betrayal
By my eyes and ears
An un-choreographed dance
Alone

Angela McVey

Dizzy Up the Girl
Ménière's 8 years

I'm Not Drunk
Anne Elias
Pencil on paper

I am sitting in the gutter.
I am not drunk.
I have Ménière's disease.
Please help me!

Ménière's since 2015

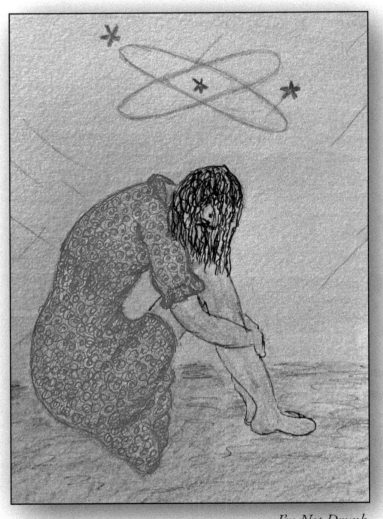

I'm Not Drunk
Anne Elias
Pencil on paper

Typically I open a letter with 'Dear—'.
However, there is nothing about you particularly dear to me,

Mr. *Ménière's,*

We have been acquaintances for 18 years, but you were in my life long before I knew your name. You were every episode of motion sickness, tripping over my own feet, and falling over air throughout my childhood, weren't you?

It's OK if you don't admit it. We both know it.

I could tell you all about how much you have ruined my life or how angry I am that you and I remain acquainted after all this time.

But I won't. You don't get to have that power.

I won't lie and tell you that you have ruined my life, because that isn't true. You have enriched my life. Let me explain …

Because you stole most of my hearing, I have become a better listener.

Because you are so picky about body chemicals, I make healthier choices.

Because you steal my balance, I have become more grounded.

Because you make me sick, I have become a healer.

Because most days I am exhausted from merely existing, I am learning to appreciate rest.

Because you tried to isolate me, I created a support group!

One great thing about social media is it allows you to connect with people on a particular subject or idea. One of the shocking things about you is how many medical providers have never heard of Ménière's DISEASE. I'm saying your name, because it needs to be said until someone hears it. You thrive in isolation.

I created *Spin Cycle*, an online Facebook support group for people who, like me, refuse to let you win.

We are warriors.

We are survivors.

There are more than 3,700 people who are acquainted with you and who refuse to let Ménière's DISEASE win.

We share stories, experiences, recipes, tips and tricks for surviving Ménière's DISEASE.

We joke and laugh and cry and vent and celebrate and mourn.

We are grateful for each other, and we are a family.

There is always room for more of your survivors in our group. There is always a place for them where *you*, Ménière's, are not welcome. We do not have to be alone. More people will understand than what you let us believe. You whisper your venom in our ears, tell us that we are alone and worthless and sick and useless.

But you're lying.

We are NOT alone.

We are NOT worthless or useless.

We are sick, but we are NOT dead.

We are stronger despite you, and We. Are. Coming. For. You.

Jen

18 year survivor
Facebook: Spin Cycle Admin
There is always room for you.

Alone
Julieann Wallace
Photography

The beach is my most favourite place to be. It reminds me of childhood holidays of surfing the waves, effortlessly floating in the salty ocean, being dumped after the curl of the wave that I wasn't quick enough to dive through, building sandcastles with moats, walks at sunset and inhaling the fresh salty breeze.

Peace. Relaxation. Happiness. Freedom.

When I was walking on the beach in 2022, I focussed on the footprints in the sand. The foaming waves trying to reach this one footprint fascinated me. When will the footprint be consumed and sucked into the ocean as if it never existed? Erased.

This lone footprint is me as a grown-up. 28 years with Ménière's disease. It represents what I have felt throughout my journey. *Alone.* Except for my faith. None of my family or friends can ever understand exactly what it feels like to have Ménière's. They don't realise the deep cost to my being of what the disease has truly taken from me that I have hidden from them with my faking being well, the pieces of me blown by the wind to the secret places of the earth.

If I look long enough at the photograph, I can picture the footprint as Ménière's disease, and I can see the foaming wave wash right over Ménière's disease, erasing it for good, with the taste of salt, our enemy, for good measure.

Ménière's since 1995

Alone
Julieann Wallace
Photography

Dear *Tinnitus,*

It's 3 a.m.

Time to turn the volume down,
Listen for silence.
Do you tire
Of the sound of your own voice?

I hear the storm brewing,
And, with it, you roar!
Thunder to the lightning,
The rain on my parade.

We're dysfunctional, you and I.
You scream
And I second guess other voices.
Are they real or is it just you?

You pretend to be harmless
A murmur that others can't hear
I lie, "I'm fine."
My eyes show fear.

Let's take a break
A breath, a pause.
You're waking dizzy
He's in my head.

We're not equals,
You'll always win.
The leader of a gang,
Me, a sole fighter.

The sun will come out,
Your power will deplete.
I'll wait till then
Sleep incomplete.

How do I sign off
When you're coming with me?
I lay the pen down,
And you lie down with me.

Roshini Suparna Diwakar

Ménière's symptoms: 2 years
Diagnosis: 1 year
Website: theglasselevator.in
Instagram: @chochin_sd

Turn
Kathleen Ney
Charcoal

While I was having a long remission period from Ménière's,
I regularly attended figure drawing sessions for fun and
practice. Initially this piece was done as an experimental
way to create abstracted drawings. But I realized my ever
present fear of the vertigo coming back had crept into the
work and that it expressed how it can feel with vertigo, an
out of body experience and disconnected to gravity. Since
this drawing I have created many abstracted pieces which
I think a variety of people can relate to, this particular
drawing sold fairly quickly.

If you'd like to purchase a print of this image, with a
percentage going to vestibular disorders research, you can
contact me at *www.kathleenney.com/giclees.*

Ménière's since 1999

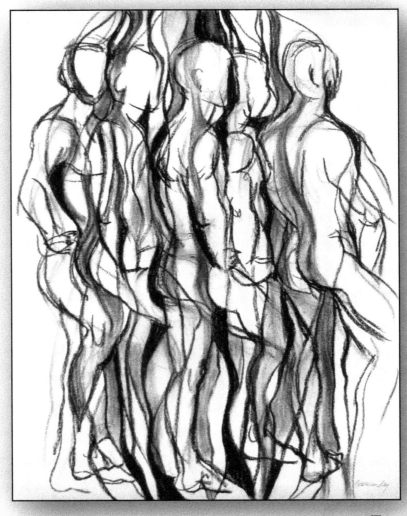

Turn
Kathleen Ney
Charcoal

Hey *Ménière's!*

You may not be life threatening but you are most definitely life altering.

Because of you I missed my daughter's grade 12 graduation.

Because of you I missed my dad's 70th birthday party.

Because of you I missed Christmas Day celebrations with my family.

Because of you I'm unable to go to concerts or movies anymore.

Because of you I'm unable to drive anymore.

Because of you I'm unable to work anymore.

Because of you I'm no longer an independent spur of the moment person.

Because of you I can't commit to anything because I never know how I'll be feeling until the actual moment.

Because of you I've had to lie in my own urine & faeces for hours until the spinning finally stopped.

Because of you I've missed too many milestones & memories to count...

However,

Because of you I have found an inner strength I never knew I had.

Because of you I have found out how much I am loved.

Because of you I have found my passion for gardening.

Because of you I know how to appreciate little things that others take for granted.

Because of you I am grateful for the good days.

Because of you I know I am strong enough to get through the bad days.

Because of you I have more empathy for others.

Because of you I love deeply.

I really wish you didn't intrude on my life all those years ago and I hate hearing about others lives you have invaded.

My sincere wish is that every other person who also deals with you will soon come to realise that they are stronger than you and you won't break them.

Sincerely not yours,

Nicole Howe

Ménière's disease since 2007
Instagram: @thebotaNicroom

Dear *Ménière's,*

There are a few things that I would like to tell you. First and foremost, you are taking away my hearing, and you are replacing it with all sorts of "wonderful" noises—sirens, fog horns, crickets, mosquitoes, bells, high pitched whines, just to name a few. I do not remember the sound of silence.

You have taken my balance. Yes, *my balance.* So, when I walk, I look like I'm drunk. Funny thing is, I don't drink adult beverages, they only make you worse.

You have taken my ability to drive. This is huge. I used to photograph the northern lights. I can no longer get up at 2 am when I get the notification to grab my stuff and run. I need to drive a bit to get out of the city lights. Speaking of running, you took away my ability to run. I did a few 5K's before diagnosis. Now, yeah, I can just see me trying to do a 5K with either my cane or walker!

You've taken away my ability to provide for my family. Besides making it impossible for me to work, I cannot take part in dipnetting in Kasilof (we stand in the river with nets that are 5 ft in diameter and pull salmon out of the river). Now, I have to proxy someone to get my fish. You also took away my ability to hunt. Once again, someone must be my proxy.

You've taken away my ability to pack up grandkids and take them camping, just plain old fishing in the creeks, or going to the park.

Oh, and thanks to you have I have fallen several times. I've broken both of my feet multiple times from falls called drop attacks. You also knocked one of my lumbar vertebrae out of place which resulted in back surgery.

If I am lucky enough to go to the grocery, I have to be extremely careful. The rows and rows and bright lights—forget it. Dizzy to the point of vertigo.

Now I don't want you to think you have done nothing good for me. You've given me one thing. Princess Parking. That's right, I get a handicapped placard for my husband's car. So, any time we go out, we get to park by the door. For that I thank you. Especially in the winter here in Alaska. Those parking lots suck eggs. So, my last words to you are these: CHUCK YOU, FARLEY!

With my worst regards to you,

Cathy Hosler

Ménière's disease since 2017

Dear Me,

The message is so simple, yet it gets forgotten.

The *people* living with the condition are the *experts*.

Let's help the experts to understand.

Love,
Me
P.S. Thank you Michael J. Fox

Dear *Ménière's Disease,*

It's now 10 years since we first met on a romantic long weekend in Venice. There were three of us on that holiday when our relationship first started and there are three of us in our relationship now. We have however, all learned to get along fine and live happily together.

I have many memories from that first weekend which was an indication of what you would bring to my life, my family and my relationships.

The beautiful water bus trip down from the hotel into Venice city centre on the first day. I suffered a vertigo attack sitting at the back of the boat and could not stand up to get off the boat. We had to go round and round the circular route for 2 hours before I was steady enough to get off and stagger to a seat on the jetty.

The second day in the most famous café in Venice, the waterside Caffè Florian, my second vertigo attack occurred. I just managed to get to the toilet where I put my head down the bowl, vomited and passed out, waking up a minute later to find my head stuck down a very prestigious "u" bend.

That night I looked you up on the Internet and realised you were going to be with me for the rest of my life.

But we know each other well now. You have introduced me to some amazing friends. You have sent me on an amazing journey searching to gain health knowledge.

You have happily integrated into all aspects of my family life.

Now we are at peace.

John Ingram

Ménière's Disease 10 years
Facebook: Deaf to Ménière's Admin
www.deaftomenieres.com

There once was a man with Ménière's,
A condition that nobody envies,
His balance was gone,
He spun like a con,
And cursed the disease with his energies.
He'd wobble and sway all around,
Like he was perpetually off-ground,
His ears would just ring,
Like a school bell's ding-a-ling,
Making him feel like a clown.
He'd curse the disease with all his might,
Hoping to make it take flight,
But Ménière's stayed put,
Like a pesky old coot,
And kept him spinning all day and all night.
So he learned to live with this fate,
And made Ménière's the butt of his hate,
He'd joke and he'd jest,
With humor that's the best,
And made the disease seem second-rate.
Now he laughs at his Ménière's plight,
And curses it with all his might,
But deep down he knows,
That it's just one of those,
Things in life that he can't set right.

Angela Selar, Sourish Chanda

www.giddygabby.com

Fatigue - a self-portrait
Steven Schwier
Acrylic paint on canvas

My art is a window into my soul. Although dark, demented and disturbing, it's the real me. If I didn't feel the way I do, I wouldn't paint the way I do. My soul on canvas I guess.

This is me with fatigue a symptom of Ménière's disease in my artistic expression as I feel them. The brushstroke does not lie!

Ménière's since 2012

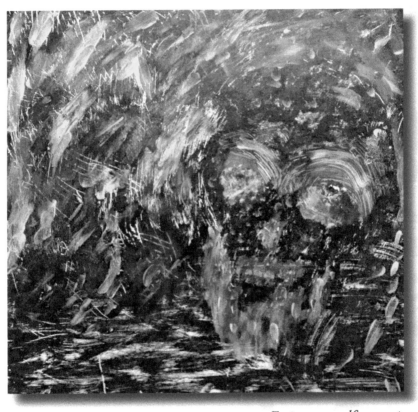

Fatigue - a self-portrait
Steven Schwier
Acrylic paint on canvas

Dear *Ménière's,*

An *unsyncopated* rap ...

Let's be real. Tinnitus. Life changes. You never know what someone is going through. You're not alone. Loneliness. Fake it til you make it. Spin. Spin. Ver-ver-vert-i-go! Exhaustion. Acceptance. Recovery day. Know your limits. Don't let, Ménière's, define you. Grateful. Journal. Hearing loss.

Meh Meh Meh ... Ménière's warrior. Yeah!

In the cage. Resting is fighting. Brain fog. It's not all sunshine, and rainbows. Mourning. Feeling uncomfortable. Scammers. Misinformation. Out of the blue. Ver-ver-vert-i-go! What works for them, may not work for you!! Vertigo. Little Steps. Spinning here. Where's the anti-spin-a-dote?

Meh Meh Meh ... Ménière's warrior. Yeah!

There is always hope. Adjustments. Ver-ver-vert-i-go! Always have a back up plan. Patience. It's okay to say no. Does the weather affect you? Hyperacusis. Ménière's causes brain farts. Drop attacks. Labyrinthectomy. What to expect. Unpredictable. Helping others. Pushing through. Invisible illness. Spinning there.

Meh Meh Meh ... Ménière's warrior. Yeah!

Depression, anxiety and bad thoughts. Ver-ver-vert-i-go! Not today Ménière's! PTSD. The struggle is real!! You know what you can, and can't do. Enjoy the good days. Ménière's - it's not easy!! You look okay. Spin.
Never give up. Stop the spin.

Meh Meh Meh ... Ménière's warrior. Yeah!

The Ménière's Warrior Rapper

Dear *Ménière's,*

This is a letter to my beautiful *Hooman ... whom I love.*

I see you.
When you are well, and when you are not.
When you are spinning.
When you can't hear.
I see behind that mask you bravely put on for people.
When you're happy, I'm happy.
When you're sad, I'm sad.
When you're crying, I want to cry.
When you're unwell, I want to make you better.
I'll place my paw on you.
I'll rest my head upon you and look into your eyes.
I'm here. With you. Through the good times and the bad.
Together, we'll push through the storm, dance in the rain, and
enjoy the clear, sunny days.
Together. You and me.

With all my unconditional love, forever,
Your *Best Friend*

Cognitions of Condition
Michael Richardson
Watercolor

Cognition is impaired in a person with Ménière's disease.
The disease has taken my feeling of normality out of my
life and left me on a raft of anxiety, dizzying, different,
interacting skills and has stolen my life the way it once
was. The foggy fullness in the ear and head can have many
physiological effects – rage, anger and antisocial behaviors.
This artwork was made to help me understand myself
better with this disease. I knew the artwork was finished
because it showed what my real feelings were behind this
silent disability.

Ménière's since 2014

fineartamerica.com/profiles/7-michael-richardson
www.facebook.com/Micarikr?mibextid=LQQJ4d
Instagram: @theartistmjr
Google: Mica Rïkr

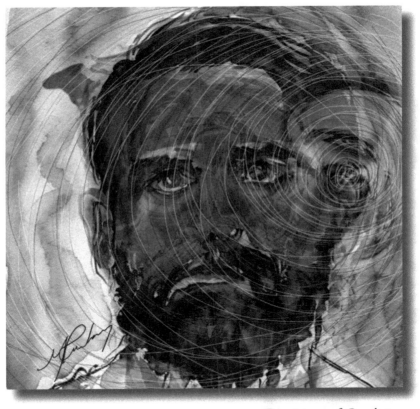

Cognitions of Condition
Michael Richardson
Watercolor

Dear *Ménière's,*

I spend another sleepless night thinking of the past and of the future that lays ahead, not knowing what life has in store for me next. My life has not been an easy one as you can tell from all the gray in the hair I have left. It's been a real struggle to get where I am. I'm facing not being able to go back to work, and life changing once again for me.

Christmas eve, 2014, my life changed forever. It was a normal day, just like any other. At 4pm I sang in the choir at Mass, and went back again at 7pm, and then home. And in a moment, everything changed. I had my first vertigo attack. But it took three years for a diagnosis of Ménière's disease.

You have taking a lot from me—my hearing, my ability to drive long distances, my balance at times and also almost lost my family because of you. What have you given me is making my life a living hell at times, plus depression and anxiety. Yeah you're wonderful. NOT!!!

I'm tired of this disease, Ménière's.
I'm tired of struggling.
I'm tired of being off balance.
I'm tired of not hearing.
I'm tired of being dizzy.
I'm tired of constant tinnitus.
I still fight every day.
I still achieve goals every day.
I'm learning sign language.
I can walk with out help now.
I'm learning to tune out tinnitus.
Soon I hope I can drive a car again.
I have been to the lowest valley and I am working on getting to the top of the mountain.

When I get there and I will the view will be the most amazing thing I have ever seen.

You will never know the beauty of the highest peak unless you have been in the lowest valley.

But Ménière's, you have also given me some really good things as well. The ability to help others, and I have made really good friends through support groups.

I still hate you, Ménière's, but I also say thank you for good things that have happened as well.

It's true, having Ménière's sometimes can feel like you're in a prison. But here's something my mother instilled in my head as a kid. Always look for the good. Always look for the positives. You'll have a better outlook on life if you do.

Remember, Faith makes things possible. Hope makes things work, and Love makes everything beautiful.

Keep fighting my friends.

Sincerely not yours,

David B. Gingno Sr.

Ménière's disease: Unilateral 2017, bilateral 2020
Facebook: Ménière's and Vertigo Without Borders Admin
Gentamicin Labyrinthectomy
YouTube: www.youtube.com/@menieresdiseasewarrior5949

VEDA
AMBASSADOR

Mother Nature Mimics Ménière's
Libby Ryding
Photography

Our physical bodies and nature are so closely in tune.
Ménière's and the weather are connections intertwined.

When the pressure in my head feels like it will explode
and I feel like going to ground I look around and see that
nature is working in harmony and I am grateful for the
realisation and answers I have found.

Ménière's for 35+ years
Instagram: @bambooandlotus

Mother Nature Mimics Ménière's
Libby Ryding
Photography

Dear *Ménière's,*

I hate you! I have always hated you!!

You first arrived without an invitation, when you gatecrashed my mother's life when she was in her early thirties. I would often come home from school as a young girl and see mum motionless on the dining room floor, under the full force of the air conditioner.

Spew bucket handy.

Towels surrounding her.

We all had to be quiet. You were visiting again.

We were not told much and my dad thought his bride was dying.

When I was 19 you suddenly turned on me too.

Then, you left me alone for about 5 years. You were saving yourself for my 27th year of life. Your return was more distressing and disabling this time and would change the trajectory of my life.

I never went back teaching and I hate you for that.

You took all of my savings.

You made me photophobic.

I was unable to tolerate the zig zaggy pattern of the carpet at the airport or strong smells like incense.

I stopped wearing perfume.

I was unable to stand between bookshelves in the library without the room turning on me and a wave of nausea washing over me.

I was unable to read anymore.

You took away my hearing but left me with high pitched, fluctuating tinnitus.

You made me nervous and unsure where once I had been strong, fearless, full of life and energy.

You took away the ability for me to walk at night without bright lights to lead the way.

I was unable to go to the movies.

I was an unpredictable friend. I still am.

I had an unsuccessful endolymphatic sac decompression.

I had unsuccessful grommet surgery.

I had unsuccessful gentamicin injections.

I asked God to take me that day, and to end my suffering before I was wheeled into the operating theatre for a Vestibular Nerve re-section, because my life was pretty much over, as I knew it, if this did not work.

It took another three years to feel like a functioning human being.

People say not to use the word 'sufferer'. However, nothing about this life with you has been anything except awful and I have suffered greatly, and continue to be negatively affected by you every day of my life.

I wouldn't wish this disease upon anyone.

Gail

Ménière's since 1996

MENIERE'S
RESEARCH
AUSTRALIA

Dear Me,

. I know it's there.
All five ugly sounds of it, louder
than anything around me.
Don't focus on it.
Use *habituation*, like
you have learned.
Tune out of it. Remember, it
takes practise, but you can do it.

Love, Me

Dear *Ménière's Disease,*

You have caused me to slow down my life.
You stole my balance, my hearing, my love for loud music,
And my love for social gatherings.

But through the chaos of you finding me, I discovered myself.
I finally became clear on what my life should look like.
A world of beauty surrounds me.
A life full of what I love.

You've turned my curse into a gift,
A chance to uplift, inspire and to dream big.
I learned passion, my drive and happiness.
There's beauty in everything, including me.

Even though you took something away,
I have gained so much.
I finally found my confidence to speak to others
And my drive to pursue my big dreams.

So, as much as you've caused me strife,
I must say that I found a new life.
A life full of beauty, success, art and more,
And for that, I am grateful.

Sincerely,

Tami Anderson

Art by Tami WI
Ménière's disease since 2019
www.facebook.com/artbytami
artbytamiwi.com

Dear *Ménière's Disease,*

For the first time in my life, I was free. Absolutely free to be whoever it is I am meant to be. Raise my kids in peace and solitude. Run headfirst into all my dreams and desires. I sacrificed my entire childhood and adulthood thus far on the altar of family. Not with any regrets though. Those choices I made, the hopes and plans I sacrificed, were worth it to lead me to where I am today.

Those I loved and cared for are gone now. Finally set free from a lifetime of pain and misery. It was supposed to be my turn to take all the lessons I learned from them, their regrets and mistakes, and transform all that generational trauma into something beautiful for myself. As I prayed for a word, a theme, for the new year, I heard "rebirth". That is to be my word, my focal point.

A rebirth unto myself. And then you came along.

Not by much surprise. The stress. The anxiety. Four decades finally caught up to me. I am angry. I am trying as I might to lean into God's promise to me of a rebirth.

A second chance at the life I've always wanted: to experience a healthy childhood through the gift of my kids, to live a simple life without feeling shame.

But it is a difficult thing to do when you are so unpredictable. I've begged God to tell me why. Why now? I've cried tears over the unfairness of it all as I laid on the couch unable to function. The fear creeps in.

But as I sit here penning this letter, I am reminded that my story isn't over yet. No. It is just beginning. Everything else was just a prelude. I didn't rise from this mountain of ashes for my chapter to end this way. There is hope and a future for me yet. I've learned how to set boundaries, prioritize my mental and physical health, and I am learning how to use my voice.

I'm not ready to thank you just yet, Ménière's. There's still a long ways to go to figure you out. But I will admit you have me backed into a corner, to face the mirror. I just can't run anymore.

Maybe this is where my rebirth begins.

Signed,

A Woman With a Story to Tell

Diagnosed January 2023, symptomatic since 2021

Balance
Julieann Wallace
Watercolour

The flamingo is the epitome of balance. In 2022, during VeDA Balance Awareness Week, I decided to create flamingo art in recognition of the importance of balance. People who have Ménière's disease often have their balance compromised, either by the progression of the disease, or by procedures performed that destroy balance cells in the inner ear to stop the debilitating vertigo —procedures like Gentamicin injected into the middle ear (like I had), Vestibular Nerve Section, Labyrinthectomy.

Imagine choosing to destroy your balance cells so you can live a better life ...

Ménière's since 1995

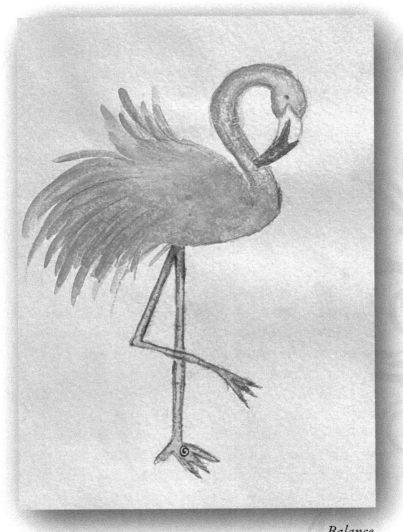

Balance
Julieann Wallace
Watercolour

Dear *Ménière's Disease,*

I hope this letter finds you well. I hope this letter finds me well.

I'm writing to thank you for your service these last seven or more years.

There have been times when I have been frustrated by you, saddened by you, and begging with you to just stop for a while. But through all of that time, I now see, you were working for me.

You help me realise when I'm letting things get too far. I know now that you're the hand on my shoulder (or over my ears) when I'm pushing too hard and sending myself down a path of bad choices. You physically stop me in my tracks, tell me to lay down on the floor and take a break.

Some days it's so hard to listen to this lesson (not just because of the deafness!) It can be hard to stop myself from pushing through the stress and strain of daily life and wanting to achieve just a little more. But with your help I've found better balance, ironic as that is.

You help me weed out the people that just don't get it, the ones that won't take the time and care to understand the limitations you place on me. You help me make sure that I make myself heard to the people around me about what I need. Every time I stand up for myself and tell someone that they need to accommodate me, it's your weight behind the words, whether it's about you or not.

I will admit, sometimes you're a little sneakier than I think is entirely appropriate. And sometimes it hurts so deeply when you punish me for stress I can't avoid and never asked for.

But I have learned to love you. And I will keep loving you because we have a long road to wobble down together.

Thank you, my beloved Ménière's Disease.

Angie

Diagnosed: 2016

Ménière's,

You're pulling me down.
You're pulling me away.
From family.
From work.
From joy.
From life.
You're burying me in a world of vertigo,
of hearing loss,
of nausea,
of ear fullness,
of brain fog,
of tinnitussssssssssssssssssssssssss.

You've taken my happiness.
My confidence.
My passions.

But my sword is drawn.
Sharpened.
I'm defying you and spiralling up,
Not down.

You will never win!

Emma

Ménière's: 26 years

Vertigo - a self-portrait
Steven Schwier
Acrylic paint on canvas

My art is a window into my soul. Although dark, demented and disturbing, it's the real me. If I didn't feel the way I do, I wouldn't paint the way I do. My soul on canvas I guess.

This is me with vertigo as a symptom of Ménière's disease in my artistic expression as I feel them. The brushstroke does not lie!

Ménière's since 2012

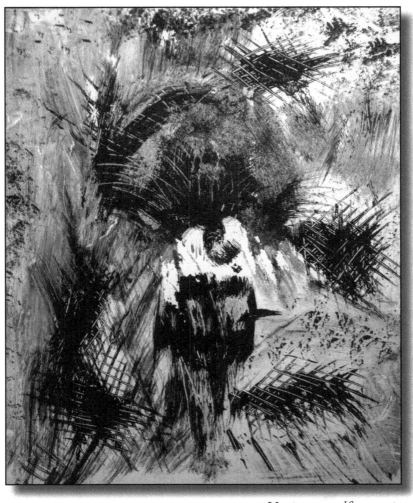

Vertigo - a self-portrait
Steven Schwier
Acrylic paint on canvas

Dear *Mum*,

The strangest thing has happened.

You know we have always said that positives come from negatives, yin/yang, good from bad. Well, it's true!

For over 35 years since Ménière's arrived uninvited into my life and brought with it so many challenges and struggles, you were always there cheering me on through the bad days and celebrating the good days.

My confidante, trusted guiding light, somewhat conservative but always sensible, caring and honest. My fellow flower and gardening lover, beach dweller, photographer and creative artisan.

When I suggested opening my little flower shop you encouraged me to do so as you knew how passionate and beneficial my work with nature is for my soul.

For years you wanted me to write a book. Even on your last days here on earth you said to me, 'Write. Write your story, Lib.'

Well suddenly the opportunity has arrived to and I have discovered that writing is indeed cathartic, you wise woman you!

My newly found connection with other vestibular warriors has brought many good things. We all have our personal struggles but collectively we have more strength and hope.

I write this to you with eternal gratitude and love, finally following your wish that I write my story and I do so in honour of you, Mumma, for all that you are and will always be - an eternal star!

I know you are smiling now, and so am I, with love and light in my heart.

Thank you,

Libby xx

Ménière's survivor of 35+ years

Dear *Ménière's*,

I fell into the darkness of your deception. *Spiralling down.*

You had me on my knees in the bottom of that dark pit, searching for the missing pieces of me, the old me. The carefree me. Grieving my lost life, praying for some sort of semblance of happiness in the chaos and uncertainty of Ménière's.

As I felt the rough, sharp ground in the overwhelming darkness, I found something. Pieces of me. Not the old me. *The new me.* Glued together with gold of the purest form, profound wisdom, and a heart of clear vision to see beyond the present. Hope. *Spiralling up.*

I reached for my gift waiting for me from above, in the pure light. My rescue. My gift of 'I am with you. Everything will be okay, in time.'

... words to read

... words to write

... words to pour from my being to help others.

Overcome. That's my word.

Plan. Seek. Focus. Mindset. Reach out. Look forward, not backward. Thankfulness. That's my doing. Every. Singe. Day.

And above all, to be kind to myself. I didn't ask for this disease. I don't deserve this disease. Nobody does.

Rebuilding. Is that what you do Ménière's?

I didn't need rebuilding. But here I am.

V1 *pre-Ménière's.* V2 *during Ménière's.* V3 *beyond Ménière's.*

Stronger and thankful.

Amelia

Ménière's disease since 2018

Brain Fog
Steven Schwier
Acrylic paint on canvas

My art is a window into my soul. Although dark, demented and disturbing, it's the real me. If I didn't feel the way I do, I wouldn't paint the way I do. My soul on canvas I guess.

This is me with brain fog as a symptom of Ménière's disease in my artistic expression as I feel it. The brushstroke does not lie!

Ménière's since 2012

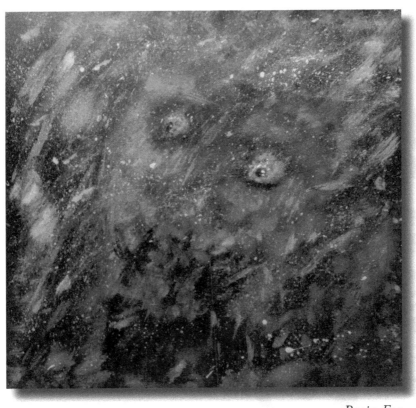

Brain Fog
Steven Schwier
Acrylic paint on canvas

Dear *Ménière's Disease,*

You turned my life upside down and inside out (literally and metaphorically) before it even really had a chance to begin.

If I had a choice, I would never choose you. But I can choose to see you clearly, and now that time has passed, I can see the silver lining, too.

Before you arrived in my early twenties, I took life for granted. In my young mind, I was invincible. My health was guaranteed. My balance was a given. To say you were a wakeup call would be an understatement.

When we first met, I had never known hopelessness so deep. Despair so dark. You brought me to my knees, and I almost gave up entirely.

You were my personal terrorist. I hated you with every fiber of my being. Hated what you took from me. Hated how you made me feel so weak and powerless.

But now 12 years have passed since I first learned your name. And sitting here today, writing you this letter, I'm a different person than I was before. I'm happy and content, and I have been for long time now. I live an amazing life, filled with love and purpose and meaning, and I can see with perfect hindsight that it all started with you.

Because of you, or in spite of you, I took ownership of my life and my health. You gave me limits I didn't want – limits I'd never faced before – but I still found a way to do the things that mattered most to me. I found a way to grow. I found a career in helping other people who were still afraid of you. I found a beautiful family with a loving wife who gave me two amazing children. I found a life I'm proud to live.

You changed my world completely, and yet somehow, in all the ways that really matter, I can see now that it was for the better.

If I could erase you from my life today, I would do so without hesitation. But enough time has passed for me to recognize that I wouldn't have this life I love if I had never met you.

It's such a strange contradiction: I wish you were gone and yet I'm deeply thankful for what you've taught me, for what you've enabled me to become.

And for that, I can say without hesitation, that I am truly grateful.

Yours (but hopefully not forever),

Glenn Schweitzer

Ménière's since 24 years of age
Author of Mind Over Ménière's and Rewiring Tinnitus
Tinnitus Coach
Mindovermenieres.com
RewiringTinnitus.com
Facebook: Ménière's Disease Support Group Admin

Mermen
Carol Esch
Quilt

Ménière's can affect every gender, race, sex and age. It's been described to me as waves coming and going and being surrounded while trying to navigate life successfully. I've only suffered two bouts of vertigo and one just threw me out of my bed. Thankfully it was temporary but Ménière's is not temporary.

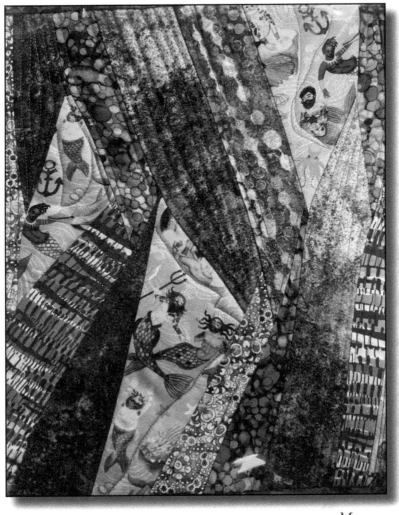

Mermen
Carol Esch
Quilt

Dear *Ménière's,*

I hate it with a passion how you ruin peoples lives
How you silently crept into our peaceful life
Encroaching on our health, careers and more.

You make it so difficult for our relationships with families,
Friends and our husbands and wives.
How can I explain to others what I don't understand myself anymore
I want to express the hardships you cause me
But there just really aren't the right words for.

This rollercoaster ride is relentless and exhausting
Life constantly requires so much care to avoid any triggers.
Remembering how I move my body, my eyes, avoiding salt,
Avoiding caffeine and fries.

The tinnitus is so mind numbing, it's constantly strong
I just get so dizzy and can't focus on anything for long.

Earaches, headaches, insomnia and general malaise,
Brain fog, confusion and vertigo that goes on for days.

Sometimes I feel like I'm losing the plot,
It's so bloody tiring, I need to rest a lot.

Even my vision can get blurry and hazy
I'm not crazy or even a little bit lazy.

You've stolen so much life away from us all
But be warned, we aren't always worriers,
But a powerful tribe of Vestibular Warriors.
When you try to steal all our hope
We just turn around and learn more ways to cope.

Should I thank you for making me fight you and be stronger?

No, I don't think so ... I simply keep striding ahead to my life,
With you in it no longer.

Vestibular Veronica
Ménière's survivor of 35+ years and counting!

Nuances
Libby Ryding
Photography

The correlation and beauty of the intricacies between natures design of the nautilus shell and our cochlear and vestibular system. Reminding me of the similarity between my slightly broken Nautilus shell which mimics my slightly broken self.

Ménière's: 35+ years

Nuances
Libby Ryding
Photography

Ménière's,

I can't say *dear*, because you are not!

In 2006 you took away everything, *everything*: my job I had been looking for, my driving independence and my balance!

For along time I was angry and depressed.

Thankfully I have a very understanding husband and son, who made me understand that I have things I can do. It took me a long time to remember that.

I am doing much better, there are days I feel sorry for myself and forget the things I am able to do but with the help of my God, husband and son, while I am still imbalanced, I do the things I can do !

Sincerely,

Peg

Ménière's disease since 2006

Dear *Ménière's Disease,*
Vertigo, Hearing Loss, Brain Fog, Left and Right Ear constant high pitched Tinnitus, Dizziness, Exhaustion and Irritability,

You don't have victory over me anymore. I live my life as if today was my last and choose to see life as an adventure. I take breaks as needed without feeling guilty! Taking time to take care of myself is finally on my priority list and not at the bottom anymore. My days of frustration are fewer and fewer.

After being diagnosed over 18 years ago with you, I have learned to cope in different ways and not let these burdens weigh me down anymore.

I do what I can and smile as much as possible.

I will enjoy the sunrises and sunsets.

I will stop and smell the roses.

I will enjoy my life and praise God for each breath I breathe.

I will eat what is best for me and stay as healthy as I can.

I will enjoy my family, and treasure each moment and memory made with them.

I have wasted enough time not enjoying my life and worrying about "what ifs".

Not yours anymore,

Donelle

Ménière's disease 18+ years
www.inkedprints.com

For God has not given us a spirit of fear,
but of power and of love and of a sound mind.
2 Timothy 1:7 NKJV

I can do all things through Christ who strengthens me.
Philippians 4:13 NKJV

Vortex
Shez Kennington
Acrylic on paper

The vortex represents the feeling of heading into a
Ménière's vertigo attack. That feeling of falling that seems
to have no end, round and round into a dark hole ~
drowning with no immediate escape …

Ménière's since 2009. Bilateral.
https://www.facebook.com/blueflyillustration
https://blueflydesign.wixsite.com/blueflydesign
Illustrator of Meniere's picture books:
Vanilla Swirl and *Blueberry Swirl*

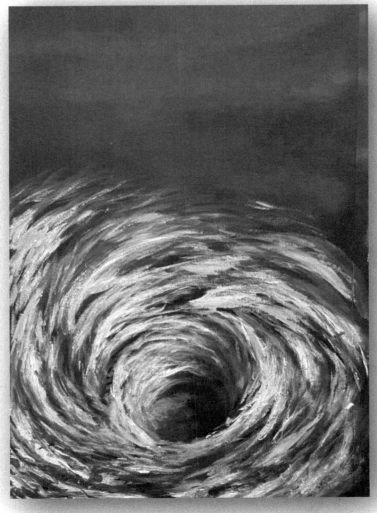

Vortex
Shez Kennington
Acrylic on paper

Dear *Ménière's,*

the space that you take up
 is the space that you want
i am a traveller in this world
 of spinning dreams and sirens

crashing into my world unasked
 you entered it willing to rule
not realising that i was already sovereign
 and ready to defend my state

but like the war of the roses
 this story will be a long one
and my decision is a truce
 you can stay in peace

i will breathe in the chaos of it
 and you will be managed
together we will dance the fuzzy sea
 of this strange reality

There is a liminal space between dreaming and awake where my mind is both in this world and between worlds. Time cannot exist in its regular linear fashion there. I hardly exist as a manifest physical being - instead I am a fuzzy concept that once had firmer boundaries but now sits waiting to be wholly firm again. It's a magical place, but a scary one. What if I get stuck there and never reform into the Gemma that I knew before? What if this vague swimming version of reality lasts forever?

When you first came to me, Ménière's, I focused on the violence that you brought. The rough, spinning, lurching, swaying, screaming of it all.

You were extreme. You took over my body randomly, terrifyingly, and completely. Now I realise that you routinely take me to that liminal fuzzy place too. You are a paradox of extreme movement and complete loss of movement. You are the most beautifully horrible reminder that this body is stable only in as far as I can remain stable in it.

So each day, I breathe.

I take you as a reminder to stand in my strength and rest and to flow in the liminal. I'm not perfect at it. I try to control reality. I get caught up in the drama of the day to day, I overthink, and involve myself in the pain of the world to a degree that I sometimes cannot manage.

And every time you're there to remind me to stop.

To slow down.

That I am not ever really in control.

So thank you, I think. I'm not sure.

You're a strange friend to have, but I don't think I have a choice but to work with you.

Love,

Gemma Lucy

Ménière's diagnosed: October 2020
www.instagram.com/gidiathegem/
linktr.ee/deepsealights

Fine

It's a great day today. My head is clear.
Tinnitus is low. No nausea. My balance
isn't too bad. No vertigo on the horizon.
I've got a spring in my step.

Change

I don't feel right. Tinnitus is louder.
Nausea is swimming.
I have movement sensitivity.
Hyperacusis. Brain fog.

Stormy
Not looking good today.
Tinnitus is impossibly loud, balance way
off, bobblehead, nausea, vertigo any mo-
ment now - it's like a ticking time bomb.

Catastrophic
KABOOM! Violent vertigo.
I can't move my head. I'm done.
Someone, please make it stop!

Ménière's Forecast
Julieann Wallace
Digital on Procreate

Ménière's since 1995

Dear *Ménière's Disease Researchers,*

Thank you. Just thank you. I know the inner ear is a difficult place to research. I know the inner ear is immensely complex. But thank you for tackling the almost impossible for us.

We're all counting on you.

I'm feeling so low because I can't work because of my vertigo. How do I feed my kids? How do I pay my mortgage? How to I pay for my medication? How can I buy my wife some flowers to say thank you for caring for me? I should be caring for her.

I'm counting on you.

How do I get disability allowance, or sickness benefits when the assessors don't believe me, even with a letter from the GP or ENT? <u>Why are they left to make a call on my life and my suffering?</u> I don't understand. It not only affects me, it affects my entire family. It affects my mental health. Who wants a depressed father who becomes a burden on everyone? <u>How can their decision override that of a medical specialist?</u>

I'm counting on you.

I'm hanging in there. *Just.* I have contemplated ending it all. Then I wouldn't have to suffer the horrendous vertigo, hearing loss or tinnitus anymore. But my wife and kids need me.

My hope is in the day when a successful treatment is found.

We're all counting on you.

Thank you,

Justin

Ménière's disease since 2000

Dear *Ménière's,*

Dear Me,

Anxiety. Panic attacks.
Remember, I've survived the anxiety of
Ménière's disease so many times before.
I can do this!

 Breathe in for a count of 4.
Hold for a count of 7.
Breathe out for a count of 8.

And repeat. There. That's better.

Love, Me

Dear *Ménière's* disease, **Vestibular Migraine,
Benign paroxysmal positional vertigo (BPPV), Acoustic
Neuroma, Hearing Loss, Insomnia, Brain Fog, Anxiety,
and Tinnitus,**

Go to hell and don't come back.
I'm in a race I don't wish to be in, but I will WIN.

Adrienne Smith

Ménière's diagnosed: 2015
Facebook: Ménière's: On The Vertigo Admin
Ménière's Worldwide Admin

Dear *Ménière's Disease,*

You're funny but not really!

When I was a kid my friends and I would swing on the clothesline laughing like crazy. It's steel arms holding us as we whizzed around in a little see-sawish motion before flopping to the ground dizzy, falling over each other laughing while our heads were spinning. The games we played as kids like ring around the rosy, a tissue a tissue we all fall down! We thought it was so funny!

Funny thing life, it's so ironic isn't it?

You play tricks on us. These days I get dizzy and spin with vertigo without even enjoying the celebration of parties, swinging on clotheslines, sailing on boats or other random adventures. I always try to find the humour still. Some days I'm so clumsy dropping things, forgetting what I was going to say, bumping into walls and tables, that I can and do laugh at myself.

Other days it's not so easy to find the fun like I did when I used to fall off the clothes line laughing and fall to the ground. I wish it were.

These days falls and my aging body are not as compatible as when I was a child. Now I'm more than likely going to end up with broken bones, teeth or dinged in some other painful way.

So, let me just say this Ménière's, may I have my old life back please, the one without you in it!

Bugger off,

Mad Muriel

Ménière's disease 35+ years ago

Ménière's
Lynne Gibbs
Pastels and pencil

My art is an attempt to convey the absolutely dreadful symptoms of Ménière's. I have suffered from it for *62 years* now—the motion sickness, the dizziness, the headaches, the nausea and uncontrollable vomiting. So many extremes of emotion when trying to cope with all of it! At times and I have to scream out to my family for help! My daughter told me it's hair raising at times to suddenly hear such a dreadful wail.

My grandchild, produced this piece of art to describe the suffering I go through. When I cry for help my daughter literally runs up our stairs, calling out, "Oh no, mum, not again!"

My grandchild has stood beside me, watching the varying colour tones my skin changing during an episode. As at first it can be white, then have very blue tones and when the medication ceases to help me, I change into dark, blood red tones then as the vomiting sets in! My grandchild said to me, "How I wish there was a way that all this could stop for you! Your suffering is so terrible to witness."

Ménière's for 62 years

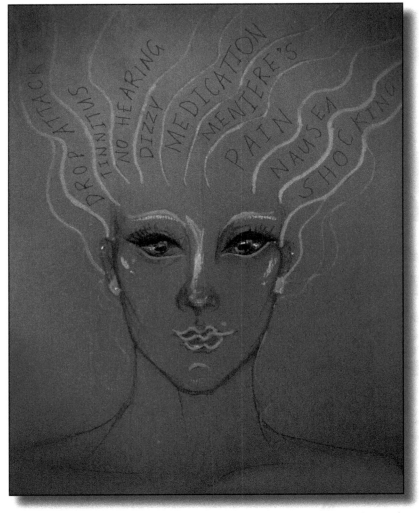

Ménière's
Lynne Gibbs
Pastels and pencil

Dear *Ménière's,*

You thought you were going to destroy me
and my life.
Well you better think again because here I am still
moving forward after 56 years of your torment.
Now get the message, and get lost!!!

Lesley

56 years of MD

Dear *Ear*,

 I'm writing to you mostly because I love the rhyme '*Dear Ear*', and despite our sometimes tumultuous relationship, I love you, too. I so enjoyed seeing you this morning in the mirror, looking as if you're any person's ear.

 I've been thinking about it all day, the way you looked. Silent and innocuous, which is nothing like the you I've come to know. I feel I should tell you that you don't have to pretend if you don't want to.

 I remember the first time we got into a row. You told me who was boss and I believed you. Why do you hide that part of yourself in the mirror and sit there all pina in auricular style, all lobate, all Surrealism and cartilage baroque?

 Wouldn't it be a gas if you twitched to show your dominance, or if lightning rods or a series of small arcs surrounded you as if we were in a comic book?

 Anyway, have a think about what you might bring to the mirror next time. It'll be fun, unless it's horrible – whatever the case, we'll survive.

Yours in sickness and health and especially the in-between,

Heather Taylor Johnson

Ménière's disease since 1999
Author - www.heathertaylorjohnson.com

Ménière's Chaos
Julieann Wallace
Acrylic paint on canvas and paper

Ménière's Disease.
Unpredictable. Chaotic. My unfriend.
A lone tree sits on a hill, bracing for the vertigo, tinnitus
and hearing loss of Ménière's disease to come. The swirling
background is the chaos and unpredictability of the
unknown of each moment, each day, each breath, mixed
with anxiety and brain fog and the whistling incessant wind
of tinnitus. The brown musical swirly leaves are about to
drop because of loss of hearing, and the spirals in the tree
represent vertigo about to hit an any given moment. This
is the unpredictable, chaotic and unsettled life of living
with the Ménière's monster. The sun is painted in the style
of *Vincent van Gogh*, paying homage to him, as medical
researchers believe that he was not insane or epileptic,
but, after reading and analysing the symptoms he suffered
his 820 letters, that he in fact suffered the symptoms of
Ménière's disease.

Ménière's since 1995

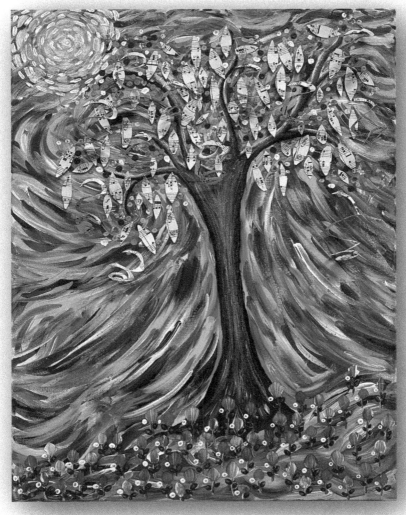

Ménière's Chaos
Julieann Wallace
Acrylic paint on canvas and paper

Dear *Ménière's,*

As a musician, I'm devastated by what you're doing to my hearing and my life.

Do you know that because of you, I can't play my grand piano when you're around, because the resonance is torture and sitting upright makes me dizzy?

But you won't win, because I can play an electric piano with ear phones and I can compose on a lap-top with my head supported and keep making music.

Do you know how hard it is to go to crowded gatherings, concerts, parties, the movies, and how disappointing it is not to see my colleagues perform in their shows? But you won't win, because my friends understand.

Do you know that it's not just me you effect? It's my whole family - my elderly mum who'd love more visits, my husband, who adjusts his life for me. I can't drive anymore and I can't mind my grandkids on my own. But you won't win, because we're all working together.

You're a mean one Ménière's, you're part of my life, but you can't win because I find ways to keep you at bay, like not eating my favourite foods like salty anything or chocolate. (I hate you for that!)

I'm determined to make you as small as I can because I am bigger than you. When you attack me, I'll fight back as best I can, with serenity, patience and knowledge and you won't win.

I am not you, Ménière's and you are not me, you're a freeloading, unwanted guest, so behave and be quiet. And when you won't, I know that your full-eared fogginess, your hurtful sounds and dizziness won't visit for long, so I win. I can even ignore your irritating ridiculous tinnitus. So there.

Vicki Larnach

Ménière's disease 6 years symptoms from 2017, finally diagnosed in 2020
www.goodomensthemusical.com
www.facebook.com/vicki.larnachhare

Ménière's Monster,

You appeared when I least expected. The first time was like the second, the third, the fourth … on and on and on and on …

Just to remind you, the first time you appeared was when I was in restaurant with friends when suddenly I felt horribly strange. I got up to go to the ladies but as I stood I was really dizzy. I couldn't stand or walk. The world started to spin. Absolutely terrifying. I was carried out of the restaurant, put into a taxi and threw up for the entire one minute of travel (I lived around the corner).

Believe me, the taxi driver was not happy!

For the next six hours, I continued to vomit while the world continued to spin … but you didn't care. The next day, I assumed it was a serious case of food poisoning, so I rang the restaurant to and let them know. It wasn't until many months later I found out the culprit was you! You monster!

You continued to sneak up on me when I least expected. You were relentless, plotting and planning your next move. Well, you certainly achieved that.

You could at least have given me some warning so I could find a safe place. But no, for years you continued attacking me in restaurants, at work, on the streets, at home, on trains and each time it was a full blown episode. If not an episode I was constantly dizzy, stressed, traumatised not to mention the ongoing brain fog.

You took so much away from me and I hate to admit: You scared me! *Well*, I thought: *Enough is enough!* You had no idea who you were fighting. You see, I will not be controlled by anyone, or anything! My anger is my ammunition against you, and I will fight with all I have. You don't know who you are up against, so stick that up your sneaky arse!

Dizzy Anne

Ménière's disease since 2015
Facebook: Ménière's - Sydney Support Group Instagram: @menieres_support_au
Ménière's YouTube: @menieressupportgroup-dizzy9855

MENIERE'S RESEARCH AUSTRALIA AMBASSADOR

The Spark
of Hope
Can Never Be
Extinguished!

Oh Ménière's, *Ménière's,*

I see that smirk, that smirk of smugness on your monster face. You've done something no other disease has done, you've been to the moon and back, like that saying 'I love you to the moon and back.' Well, I can definitely concur that us Menierians don't love you to the moon and back. We don't love you at all.

Not only that, you walked on the moon, hitching a ride inside the left ear of Alan Shepard. They said he was cured, but we know better, you were still lurking inside his ear, the endolymphatic shunt draining away the excess fluid so he didn't get anymore vertigo.

You tried to take him down. Did you know what he was going to do on that fateful day? Were you trying to ruin his plans like your do to ours? Alan Shepard got the better of you:

"A sliver thin, inch-long tube that doctors inserted by microsurgery into the left side of Capt. Alan B. Shepard Jr.'s head has enabled the 47-year-old Navy astronaut to come back from a grounded flight status to the command of Apollo 14 on its moon-landing mission. A Los Angeles ear surgeon, Dr. William F. House, inserted the tiny clear tube into Captain Shepard's head 29 months ago to correct episodes of severe vertigo, hearing loss and buzzing ear sounds—a triad of symptoms called Ménière's disease—that began to afflict the astronaut in 1963." (New York Times, Feb 2, 1971)

Unfortunately, the shunt doesn't work for all of us.

And golf? You were with Alan Shepard when he played golf on the moon? I wish he had packaged you inside that golf ball and smashed you off into space, never to be seen again.

Oh Ménière's. How about a one way ticket to Mars?

Always trying to get rid of you,

Jack Ménière's disease since 2017

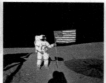

Ménière's,

I can see you hiding, why do you think I cannot see you!

I have known you since you came into my life at the young age of sixteen, right when life was getting started. Why did you stop me enjoying myself, the same as everyone else!

Then after the short time you appeared, I thought I would never see you again, and I didn't for twelve years! Those years gave me time to have a life and it was the best period of my life.

You then returned with a vengeance ... stage 2 or 3, and probably the darkest time of my entire life you stayed and sucked the life out of me for months at a time, for years, until after about five years you left again!

But I didn't let you stop me. I had one child and was determined to make sure he had siblings, although you thought you could break me, you didn't. I may not have defeated you, but I was educated enough to take you on with the tools that worked for me. You made me lose my hearing but you didn't take my spirit. You actually made me a stronger better person, the person I am today.

I am now grateful you took me on because it gave me the chance to be home with the kids and build a loving relationship and a strong foundation with them. I started out angry with you but it turns out you actually helped me. So thank you, Ménière's.

Yours truly,

Matty

Ménière's disease since 1992

Dear Me,

My best is *different* everyday, and that is okay.

Be *gentle* and *kind* to myself.

Love, Me

Dear *Friends* and *Family,*

If you invite me to an activity, I will sincerely want to come, but please don't be upset if I have to cancel at the last moment, or decline. This insidious disease is a day to day and moment to moment proposition. I thought I'd try to explain what might happen.

First, for me, there's lower ab pain and urgent need to poo, which continues as long as the attack lasts.

Then vertigo, which is not dizziness or lightheadedness; I cannot walk or stay upright—sometimes have to crawl, and the whole room moves around me. It is like riding on a child's playground merry-go-round, while drunk. I cannot get off, and then someone spins it in the other direction. The walls sway from side to side and the floor rocks like a boat in huge seas.

Although you have to go to the toilet, it is agony because that involves movement. Sometimes it takes minutes to muster the courage to tear off paper and make the tiny twisting movement necessary to wipe. Hand sanitiser prevents having to turn to the basin.

My eyes drip fluid (distinct from crying which also happens), nose runs, dribbling, coughing phlegm, peeing and sweating. It is like the body wants to expel EVERY bit of fluid.

Vomiting goes on and on every few minutes for between three to four hours. Vertigo continues. Agony to close eyes. I know when I am halfway through. An instant depression comes over me and a feeling of loss and self pity. Then I climb up again into a sense of relief at feeling able to sleep. And finally my sense of humour returns.

Eventually, when the vomiting stops, (between three and five hours later) I get so tired I am able to keep a Valium down, close my eyes and sleep.

When not having full-scale attacks, which have lessened through careful diet, good medical help, and keeping track of triggers, I often feel fatigued, off-and-on dizzy, my ear is always full, like you have water in it days later after swimming, and tinnitus. Unless you stand on my left side I probably can't hear you, and if we go for a walk together, I may well wobble into you from time to time. This is not as common now. Pilates has helped me to get a lot of control over balance!

The most irksome part now is the very low salt diet, which does help me a lot. It means going out for a meal is an ordeal of pre-arrangement. Thank you to EVERYONE who has gone out of their way to cook to my needs. I love you all!

Sally xxx

Ménière's for about 7 years

Panfish Perseverance
Tami Anderson
Chalk Pastel Drawing

Life before was a kaleidoscope of vibrant hues, bursting
with dreams, passions, and boundless adventure. Each
day was a canvas, waiting to be painted with experiences
such as fishing, kayaking, swimming, motorcycle rides,
and creating art. But that all changed in a blink of an eye,
in the midst of drawing this "Panfish", Ménière's disease
ruthlessly attacked me and dragged me down into its
clutches, holding me captive for years.

It whispered lies into my ears, telling me that the life I
adored was out of reach, and with each passing day, my
love for creating art withered away, leaving me staring at
the incomplete drawing in despair. But I refused to let
Ménière's disease destroy me completely. I summoned
every ounce of strength and determination within me to
fight back, and gradually, my energy and passion for art
returned.

I found myself drawn back to the unfinished drawing that
had haunted me for so long. I sat before it, determined to
finish what I had started. It was a struggle, but I refused to
give up until I completed it. It was a triumph, a symbol of
my strength and resilience. Looking at it now, I see not just
a beautiful piece of art, but a testament to my journey.

Life may not be as easy as it once was, but I refuse to let
Ménière's disease define me. I am a fighter, a survivor, and
I will continue to chase my dreams with every ounce of my
being.

Ménière's since 2019
www.artbytamiwi.com
www.facebook.com/ArtbyTami

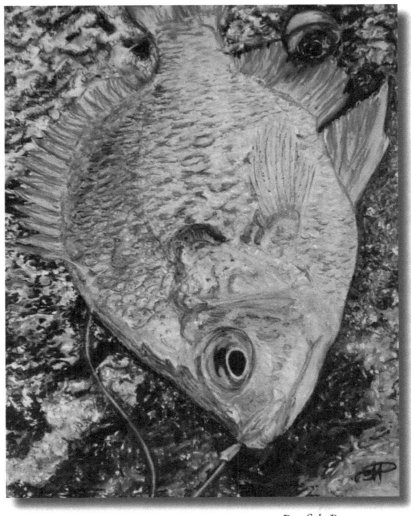

Panfish Perseverance
Tami Anderson
Chalk Pastel Drawing

Dear *Ménière's Disease,*

Drop attacks. Really? A Tumarkin's Otolithic Crisis!

No notice of an impending instantaneous fall to the ground while totally conscious. Anywhere. Anytime. Whether I'm standing, sitting or lying down at the time, you're not fussy!

Hmmmph! A rare manifestation of Ménière's disease they say.

A drop attack ... I feel like you violently and suddenly push me, or throw me, or knock me to the ground. Or I see the world around me tilt. The ground disappears underneath me like a trap door in an instant, causing me to fall. Hard. And then I get up and get on with my day like nothing happened ... unless of course I injure myself, or need to go to the hospital for a sprain, concussion or broken bones.

You are so cruel!

I hate you, Ménière's!

Fuming Fleur

Ménière's disease since 1998

Dear *Ménière's Disease,*

You chose to visit me in 2014. You were definitely an uninvited guest. I was plagued with constant vertigo and extreme nausea 24 hours a day seven days a week. I was driven well beyond exhaustion to the point of prostration. I literally lived and survived on hard peppermint candy discs. I had to relearn to walk with a great deal of Vestibular Rehab Therapy. My entire life and sense of well being was turned upside down. I was not going to let you win this lifetime battle. I fought back with all my strength and determination. I would rather be stuck all alone with Freddy Krueger than bombed by you. It took me nine long years of blood, sweat, and tears but I won! I have learned to acclimate myself to this new "life style". I know how to adapt and what triggers to avoid. I give all my thanks and praise to the good Lord above for carrying me through this life long storm. I continue to struggle with vertigo, nausea, hearing loss, and imbalance on a daily basis. I have many battle scars from traumatic falls resulting in injury and daily mishaps. So hear this Ménière's disease, you did not ruin my life and you never will. I am much stronger and braver than you think. So go buy a one way ticket to outer space and never ever show your mean and ugly symptoms on earth ever again to anyone struggling with this horrible disease. You are definitely never welcome here on earth.

Good riddance!

Marguerite

Ménière's disease since 2013. Diagnosed:2014
www.facebook.com/marguerite.mahoney.16

Mind Garden
Julieann Wallace
Watercolour & pencil on paper

In my quest to counteract the ugliness and negatives of
Ménière's disease, I use art to create something beautiful
about it. It helps me to deal with the overwhelming and
dark journey that likes to remind me of where I have been.

In this piece, the vertigo of Ménière's disease seeps out from
my left ear and into a colourful and fragrant garden in my
mind where it becomes nothing but the swirl of a light
breeze.

Ménière's since 1995

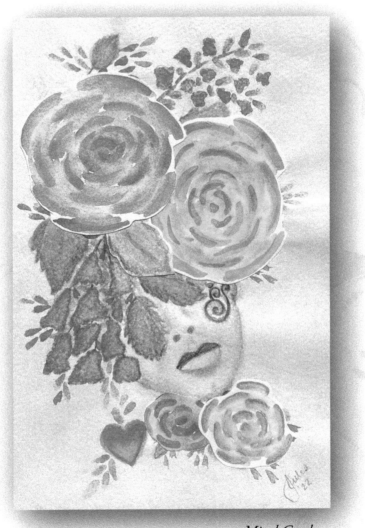

Mind Garden
Julieann Wallace
Watercolour & pencil on paper

Oi, *Ménière's,*

You have made me shed so many tears.

Tears of frustration for being unable to hear normal conversation with friends or everyday questions from my children.

Frustration for feeling like a lab rat and dealing with every side effect from medications I try, only to find the treatment doesn't work and you keep on coming.

Tears for feeling isolated or confused for what used to sound so normal and yet is a struggle today.

Tears of anxiety and despair for not knowing what you will throw at me next and how I can cope with what it will bring.

Tears for "why me"?? I already was deaf in one ear, why did you have to come along and attack my only hearing ear?!

There are tears of hope, with possibilities from the research that is being done and the advancement of medications. Hope that every treatment I try will be the one to keep you at bay.

And tears of deep gratitude, like when I can hear the music that I so fondly love or enjoy a trip to a musical or the opera. The emotions stream high when I wonder how long I will be able to enjoy these things, but I am so grateful when I can.

Gratitude for the love and support from my husband, family and friends, who help me know that I am strong when I don't feel the strength within me.

I'd love to leave you Ménière's, but it looks like you're here to stay … how about we call a truce for a while? Just so I can rest a little.

I am so tired of your antics and would love some reprieve.

No regards,

Kirsten

Ménière's disease since 2020

Drop Attack
Anne Elias
Pencil on paper

I am screaming.
I am falling.
I am spinning ...

Into nothingness ...

Ménière's since 2015

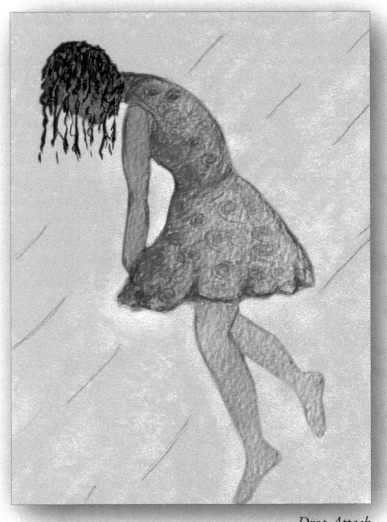

Drop Attack
Anne Elias
Pencil on paper

Dear *Ménière's,*

In September 2021, I developed sudden sensorial hearing loss after a suspected autoimmune reaction to my second CoVID vaccination. I lost 95% of my hearing rapidly, with severe vertigo episodes, diagnosed quickly as you, Ménière's.

You made my life in a high stress executive corporate job like a rollercoaster, the rides wild if not terrifying, my quality of life deteriorating significantly over several months up to May 2022.

I tried just about every MD treatment including trial high dose Methotrexate treatments in an attempt to reset my immune system, multiple inner ear steroid injections, grommets, antivirals, upper cervical treatments for months, hyperbaric oxygen therapy and low salt, no sugar, gluten free, no dairy, no caffeine, no alcohol, no meat, no fun diet.

Because of you, Ménière's, I continued to deteriorate, and during the many months off work I researched and researched, and discovered the Netherlands EDB trial and its fantastic results for MD symptoms.

It took me three ENTs before I found the right one who would listen to me, and by then my MD cluster attacks had become so debilitating and entrenched, that by April 2022, I had completely lost the will to live ...

It took numerous emergency hospital admittances and my negative outlook on life to convince my ENT specialist to push the Royal Australian College of Surgeons with the necessary research to take the surgical risk and approve it as a procedure in Australia, after initially it was a no, and too hard and expensive, as no Medicare or private insurance covered it as it was still in trial phase overseas. Ménière's, I've learnt in this game you need to intellectually push and push and push, and not just be another patient with MD.

My EDB procedure involved performing Endolymphatic sac surgery but then enhanced by pulling the sac off the dura (brain lining) and placing two titanium clips around the tube that feed the sac to permanently reduce flow of endolymph fluid.

I want to thank the Netherlands EDB surgical trials, for pioneering this treatment, and to my wonderful ENT who stood by me. We have now shared my research and this pioneering approach at the Australian National ENT 2023 conference to help educate others.

Ménière's, all your symptoms have ceased and my hearing is back at 65% loss (from 95%). I wear a hearing aid and I'm back full time at my high stress corporate role traveling the world.

And you know, after nearly a year since my EDB surgery, I never thought I'd be able to go to a concert with 70,000 people ever again, eat crap fried salty food and listen to seriously loud music.

Since May 2022, I've been vertigo free, hyperacusis free, no fullness and no tinnitus, even post three hours of rock concerts. And I know that EDB will never be for everyone, and not a silver bullet, but for me I've got my life back after one hell of an Ménière's ride.

Never yours,

Andrew Beer

Ménière's disease since 2021

MENIERE'S
RESEARCH
AUSTRALIA
AMBASSADOR

Me and My Monster
Colin (That Monster Ménière's)
Digital artwork

A representation of the two sides between normal life and chronic illness. The invisible illness lurking beneath a healthy looking human.

The Jekyll and Hyde life we live.

Colin (That Monster Ménière's) Diagnosed 2019
Instagram: @that_monster_menieres

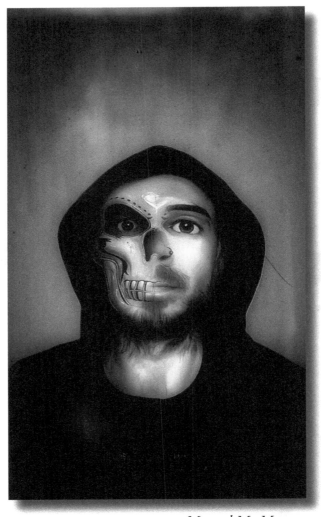

Me and My Monster
Colin (That Monster Ménière's)
Digital artwork

Dear *Ménière's*,

We first met in August, 2021. I had never heard of you previously. I didn't even know you existed. Our meeting was unexpected and sudden. We were barely acquainted before you stole half of my hearing which left me shattered and shocked.

But I am resilient. I adapted and life went on. In fact, I managed so well I was convinced that you weren't real, that maybe it was just a simple case of mistaken identity and a bit of bad luck.

Ten weeks later, you made your presence known. Reappearing with no warning to finish what you started. I was left with a more permanent hearing loss and a broken heart.

How could it be that just three-months previously my life was as I'd always known it and now, I was left with a permanent disability, wracked with fear and anxiety caused by you?

The grief passed and with it, my determination built. I wasn't going to retreat and surrender. Nine months from when our paths first crossed, I underwent cochlear implant surgery to reclaim my hearing and it was a dream run. *Fuck you,* I thought, *you can't keep me down.*

My retaliation made me feel like I had the upper hand, that I was back in control. The bitch WAS back, but my power, my rising up, it sparked a deep, deep rage in you. Then the severe vertigo attacks started.

My first attack was an entire day of being unable to stay upright. I had to crawl to the bathroom. I was drunk, on a boat on rough seas.

The next attack was akin to a three-hour scene from the Exorcist. It was actual hell on earth. I have never EVER been so afraid in my life. What was happening to me? I vomited and cried until I had nothing left to purge.

Attacks left me vulnerable and fearful. I soon found out that they're not singular and always come in clusters.

I felt as fragile as finely spun glass, driven by fear and decided I wasn't living my life like this. I could have accepted you as my lifelong fate, but FUCK that and FUCK you.

I've survived some hard things and I can fight when I need to. I'm strong mentally and physically. Do you really know who you're fucking with?

I'm not naive enough to think you'll give up easily, but here's the thing, neither will I. I have my arsenal and I'll fight for as long as I need.

1. World class ENT: *check*
2. Cochlear implant: *check*
3. Gentamicin injections: *check*
4. A body strong from over a decade of strength training and walking: *check*
5. Unwavering support of my family and friends: *check*
6. Fierce as fuck attitude: *CHECK*

So my message to you, Ménière's: I'll play the game for as long as I need to and know this - you'll never, ever win!

Sami x

Ménière's diagnosed in 2021
Instagram: @deafjamsami

Digit Therapy
Colin (That Monster Ménière's)
Photography

Throwing that middle finger up at MD has become one of my essential coping tools. I find it's a simple but satisfying way for me to deal with this life. It's a very quick action to disregard the control this disease has over me.

Here comes another attack ... fuck you! You want me to curl in a ball and cry? ... fuck you! You are making me scared of doing (insert anything) ... fuck you and fuck off!

It makes me feel like I'm winning. It creates a feeling of insulting or offending this monster, and that's exactly what it deserves. Flipping the bird directly in the face of this beast gives me power over it for that moment, and also makes me smile.

The three dots tattooed on my finger was something I had done to represent these feelings. I upped my middle finger game.

Up yours MD!

Colin (That Monster Ménière's) Diagnosed 2019
Instagram: @that_monster_menieres

Digit Therapy
Colin (That Monster Ménière's)
Photography

Dear *Ménière's*,

'Why me?' I ask myself, and, 'why not me?'
Things could be worse but boy, could they be better!
What would I say to you in a letter?
Ménière's, what would I say?
You are a horrid disease, debilitating and depressing!
A waiting game, every single day and night of
wondering, wondering:
Can I handle the tinnitus—the constant ringing white noise?
Can I handle the brain fog, the dizzy feelings, the deafness in my
right ear?
And waiting for the other side to go, as there is a familiar
feeling coming in my good ear?
I'm missing my normal life of jumping off things, head under
water, spinning, flying and not worried all the time.
F you Ménière's!
I have two sweet little babies I have to keep going for.
So F you.
'Why me?' I ask myself, 'why not me?'
Things could be worse …

Ange S
Ménière's disease for 20 years

Dear *Ménière's Disease,*

"Why me? **Why?**"

For 10 years, since 2010, we've fought over my right ear to the point where I thought I had become the stronger one ... then you decided to up the ante and take my left ear too.

That floored me. Haven't you affected my life enough?

Obviously not, because now you've taken most of my hearing in both ears. *Selfish*, aren't you?

So here I sit and write this letter, listening to double tinnitus as the keyboard clacks away noisily through my hearing aids. On bad days you win, you make me feel revolting and down in the dumps, but don't worry, I don't stay that way for long. I know we have to live side by side, but you won't win. I'm going to do everything I can to live as normally as I can, believe me.

Things I remember on my bad days to put you back in your box:

* I have an amazing husband and family—which is something you don't have. Sorry, but **no one** loves you, Ménière's!

* I can still work.

* I help others like myself, by making their lives easier with diet and products to enjoy suitable for Ménière's.

The enjoyment and fulfillment I get out of running my business to help others is enormous. If I'd never gotten MD, I wouldn't have known about this amazing community of MD sufferers and how supportive we are of each other. They're amazing, and we are here for one another.

Kim Dean

Ménière's since 2010, bilateral since 2020
www.lowsodiumfoods.com.au

LOW SODIUM FOODS
The Low Salt Food Specialists

Dear Me,

Super Survival Mode!

* Three things I am thankful for.
* Do something I can achieve.
* Do something I love.
* Distract myself from Ménière's.

Every. Single. Day.

Love,
Me

Dear *New Self*,

I hope you're feeling fine, but if you're feeling dizzy and hearing buzzing, I know how it feels with Ménière's! It feels like you have a rock concert inside your head, and you can't get out of it, at the same time you are riding a roller coaster without an end of line.

I wanted to write to you to express my concern and support, but also to bring some humor to your situation. You know, if you feel dizzy again, you can always have fun imagining like you're at a Coldplay concert that you love so much.

Seriously now, I know that Ménière's Syndrome can be very uncomfortable and stressful, but you are not alone in this struggle. I'm thinking of you and I'm here to listen and support you. If you ever need someone to talk to or if you need help in any way, please don't hesitate to contact me. I'm here for you.

Don't forget, it's important to always work with a specialist doctor to identify the cause of Ménière's and find the best treatment plan for you. And if you need a few extra laughs, remember that I am always the best person you can count in.

Again, I'm here for you and I wish you all the best things. Please keep me posted on how you are feeling.

With love and concern,
Your old Self,

Andrea E

Ménière's disease

Oh cursed disease, *Ménière's* by name,

Thou art the devil's work, a cruel game,

Thy symptoms are wicked, thy torment great,

A curse upon thee, for all time and fate.

Thou stealest balance, robst the ear,

Making victims tremble with fear,

The ringing, roaring, and endless din,

Oh how thou makest their heads spin.

Thou art a thief, a thief of joy,

A robber of pleasures, a villainous ploy,

Thou tak'st away their peace of mind,

Leaving nothing but chaos behind.

Oh, *Ménière's disease*, thou art a curse,

A scourge upon this mortal universe,

May thou be banished from this world,

For all the suffering that thou hast unfurled.

But until that day, we shall fight,

With every ounce of our might,

Against thee, vile *Ménière's disease*,

Until the end, until we are at peace.

Anonymous

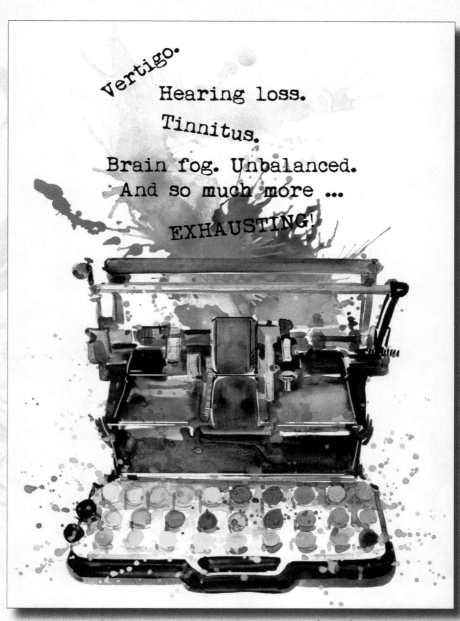

Vertigo.

Hearing loss.

Tinnitus.

Brain fog. Unbalanced.
And so much more ...

EXHAUSTING!

Mindset Changes Everything
Typewriter Art - Elena Faenkova, re-coloured and words by Julieann Wallace
Digital

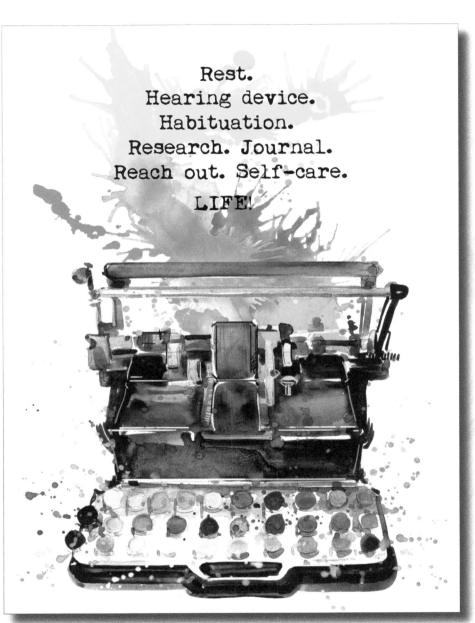

Rest.
Hearing device.
Habituation.
Research. Journal.
Reach out. Self-care.
LIFE!

Mindset Changes Everything
Typewriter Art - Elena Faenkova, re-coloured and words by Julieann Wallace
Digital

Dear *Manure* (Ménière's),

Once I was diagnosed, I felt like a prisoner in my own home for nine years.

You ruined any plans I had for a happy retirement.

Finally last year, I was coming into remission, doing the thing I love the most, walking. Then you decided to take that away too.

It was your plan to put me back in prison. So now I am bilateral.

The photo says exactly how I feel.

I will keep trying all I can with my strength to overcome *Manure*.

The only way out of this prison is death. I know you're in Hell but I am going to Heaven.

Janet Mancini

Ménière's disease since 2014
Facebook: Janet's Very Vestibular Page

Ciao *Ménière's,*

You came in and disrupted my life. You taught me so much and with the letters of your name these are things you have taught me to be, despite the symptoms. I'll use them the rest of my days.

M.otivated
E.mpathetic
N.uturing
I.nspired
E.nthusiastic
R.esilience
E.ducated

I'm prepared and ready for any further lessons you have for me.

Ciao,

Ménière's disease since 2017

Blindsided
Daniel Pancy
Acrylic paint on canvas

Through my art, I am teaching others about life as a person
with Ménière's. I am allowing those with Ménière's a
chance to show and explain to their families, their
co-workers, their friends, and others, what it means when
we say, "I am dizzy."

Ménière's disease since 1999

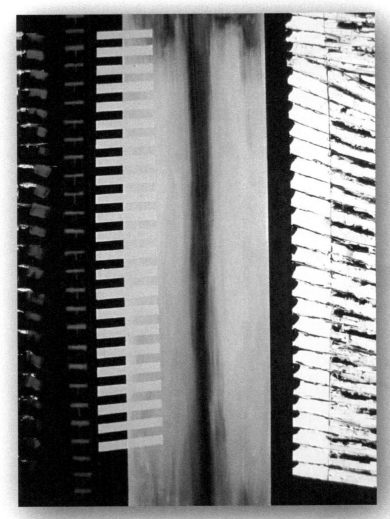

Blindsided
Daniel Pancy
Acrylic paint on canvas

Dear *Ménière's,*

I hate you.

I hate that you've taken so much from me.

I hate I have PTSD every single day and night because any dizziness, unsteadiness or tinnitus, straight away makes me believe I'm going to have a violent vertigo attack.

I hate that I'm scared to go for a walk with my two toddlers because, what if I have an attack while walking near a road? What if I'm too far away from anyone and my children run away from me?

I hate that my partner thinks I'm an unfit mother because an attack can come at anytime while taking care of the children, and I often have to rest in bed.

I despise that if we were to break up, I've been told he will get full custody due to him being primary carer while I was sick with Meniere's disease.

I hate that I was so stupidly obsessed with sign language and deaf culture as a child at school, and now I'm profoundly deaf in one ear.

I hate I have to wear hearing aids that itch and don't really help that much.

I hate not being able to hear people when they talk to me.

I hate having to constantly say, "Sorry, I'm hard of hearing" to anyone trying to talk to me in a mask.

I hate that I have to take medication every day.

I miss drinking coffee and energy drinks.

I hate that every second of every day I'm scared I'll develop drop attacks.

I'm scared I won't be able to work due to this.

Ménière's, I hate you with every fiber of my being!

Nora

Ménière's since 2017

Dear, Dear *Ménière's,*

I'm so sick. I'm deflated by people telling me how well I look ...
So I must be fine, mustn't I?

When in reality, I have tinnitus so fluctuating that I'm
struggling to hear ...

And oh, I may also be quietly throwing up in my mouth, and
managing to swallow, so I don't upset anyone around me, family,
friends, colleagues

It's a continuous process of hiding what is really happening, all
for you ...

How can we make people understand how challenging you are?

How can we communicate what living with an invisible
disability feels like?

Dear, dear Ménière's, when will there be a way to manage you?
When?

Bridgena

Ménière's symptoms from 2013. Diagnosed 2020

Pain and Misery
Kathy Bonham
Collage and India ink

Steady heads are important for Ménière's disease, yet it comes with a price. Tears, frustration, isolation are only a few. Broken, disjointed and scary at times, we are like witches on the stake, waiting for the flames to end it all. Excepting the fact, it's not our fault.

Mother-in-law of a Meniere's sufferer

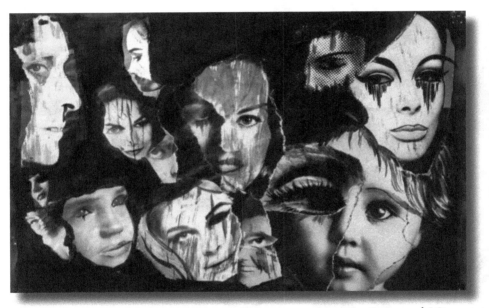

Pain and Misery
Kathy Bonham
Collage and India ink

Dear *Me,*

As you enjoy a hot cup of coffee you don't know it yet but it may be your last, along with chocolate and alcohol.

You are about to face one of your biggest challenges in life.

You probably won't believe this message because you have already lost your parents six months apart from cancer and have raised your beautiful son with special needs who needed open heart surgery at six months old.

Once you hit 50, things should be smooth sailing, right?

With two days to go before your golden milestone, aka 50th birthday, the universe will throw you a curveball like you have never seen before, and have you sidelined and in bed for long periods of time.

You will lose your hearing in your left ear, and if you think things can't get worse, you will have your world spin out of control and the only comfort you will have will be to lay on the cold bathroom floor for what seems like an eternity.

Your children will watch in disbelief as you can no longer help yourself.

Months later, after doing your own research and consulting with many medical 'experts', your intuition is sadly confirmed as you are diagnosed with a chronic illness that will shake you to your core.

You will cry, plead and beg for mercy as you lay on the floor many days trying just to survive.

You will have to surrender to the unknown and the power of this disease.

I want you to know now that you are a strong and resilient woman.

You always come out on the other side wiser and this will be no different.

You will turn inwards and work through the pain and adversity. It will feel like this monster of a disease is taking away your joy and freedom, essentially your life.

As you are trying to get more energy for daily activities you will be more tired than you have been before.

Life will seem bleak and dark.

You will not leave the house for over a year. Having said that, in that darkness something is changing. Something has been broken and shattered at its core.

You will be exhausted and your body will crash, barely able to move. However, in the dark times when you just have to lie there for hours and talk to yourself, you will see a glimmer of light, a glimmer of hope.

A glimmer of a different way to live.

Hold on to that light. It wants to teach you something. It wants to show you a new way forward.

A way to find peace and joy.

A way to acceptance and love.

Sasha

Ménière's since 2022, diagnosed 2023
Facebook: sasha.campbell.31
Instagram: @sashalcampbell

Slow Steady Threatening Cycle
Michael Richardson
Watercolor

I read Steven Schwier's story about his trip on a bike to
raise awareness about Ménière's and I thought it was really
interesting that his story had metaphors of cycling and
spinning going down long roads with flashing lights. Noise
and stress where a silent 'crack' happens inside the head
that can trigger a sudden vertigo attack at any time – just
like my own experience with Ménière's disease.

Ménière's since 2014

fineartamerica.com/profiles/7-michael-richardson
www.facebook.com/Micarikr?mibextid=LQQJ4d
Instagram: @theartistmjr
Google: Mica Rïkr

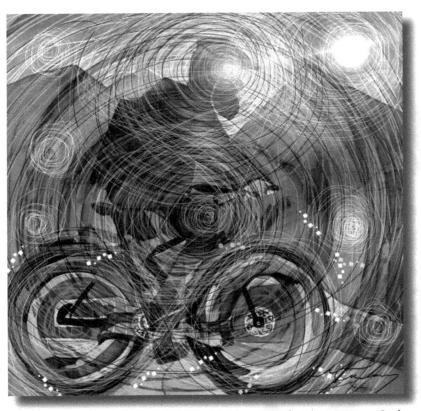

Slow Steady Threatening Cycle
Michael Richardson
Watercolor

Dear *Ménière's Disease,*

I'll never forget the day we first met. I was harmlessly conjugating verbs in my High School Spanish class when you decided to send the room spinning.

After a vomit session in the freshman hall and an embarrassing wheelchair trip out the building during passing period, I was off to the ENT for the diagnosis.

Texts from my friends flooded in the following days…

"What happened, Pat? I heard you got in a fight and got thrown down 1 flight of stairs!!"

"I saw you in a wheelchair, are you OK?"

"Were you hammered in Spanish class? … that's awesome!" I wish that was the case.

It's just some shitty condition called Ménière's that's usually reserved for people my parent's age and requires me to go on a low salt diet, manage stress, take water pills, and stop drinking booze and caffeine … don't think it satisfied the teenage gossip ich!

Despite ongoing symptoms and a plethora of depressing online articles about what our forced partnership could look like in the future, I tolerated your shit pretty well for the first 10 years.

In fact, I pretty much denied the fact that you were even there.

But payback is bitch and just as I was settling into the life of my supposed 'dreams'—steady job, beautiful wife, epic Colorado weekends—you set me right back on my ass.

The daily assault of symptoms turned a once ambitious and adventurous dude into an anxious recluse by age 31. In short, you seriously fucked my shit up.

Over time, however, I've come to realize that it wasn't the 'evil' Ménière's that led to my downfall. Nope, you just fueled my deepest, hidden insecurities until they consumed me.

It's rare in life that many of us have the opportunity to take a step back and ask the question, "Could this be better?"

Before you dropped the hammer, I was living life by the book, doing everything I was 'supposed' to do. I was living a life of fear, and I was certainly not living for myself. In fact, I was beating the crap out myself to live for everybody else.

Somewhere along the line I changed from an enthusiastic, carefree kid to a perfectionist, people pleasing work-bot who preferred late hours over friends, family, and health. I ignored the results of this self-directed stress for years, so you called me on my shit and served it up on a steamy platter.

The lessons you've taught me are invaluable:

Mental health = physical health and self-compassion is the foundation of true strength and resiliency NOT weakness. You continue to remind me of these lessons every day as I move forward into a new life of MY design.

Sincerely,

Patrick

17 years with MD and counting!
patvestibjourney@gmail.com

Loving Myself with Ménière's
Heather Davies
Sharpie Markers

Loving and accepting myself as I am with Ménière's, has been the greatest gift of self love I could ever give myself.

Ménière's disease for the past 7 years

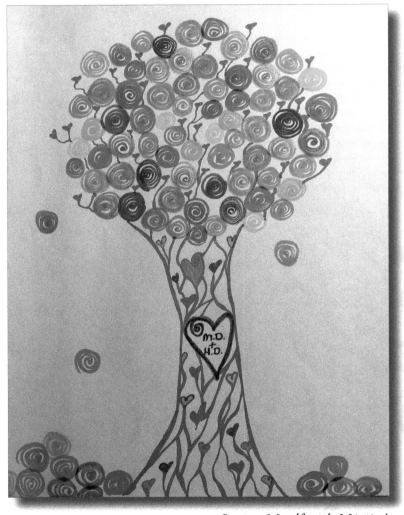

Loving Myself with Ménière's
Heather Davies
Sharpie Markers

Dear *Ménière's Disease,*

I have hated you from the moment I had my first attack in 1989, such is the poor understanding of you, I went undiagnosed until 2003.

I will never forgive you for stopping me going to see my son off on his flight, when he emigrated to Australia from the UK, because I was having numerous spins a week and couldn't travel to London from our home in Liverpool.

My mum now has terminal cancer, and yet again you are stopping me being more involved in her care.

I f*****g hate you with a passion, but together, myself and my fellow Ménière's warriors, will beat you!

Never yours truly,

Julie H

Ménière's since 1989

Ménière's,

I see them ... people suffering like me.

Nobody deserves this ... this ... manic, violent, debilitating, depressing, disgusting, deplorable, despicable, devastating, damaging, distressing, diabolical monster of a disease that makes you vulnerable and defenseless.

It takes everything, and never gives back ... it takes *everything*.

My life is nothing now.
I can't work.
I can't drive.
I can't walk without losing my balance.
I can't socialise.
I can't hear.
I can't eat what I want.
I can't ride my bicycle.
I can't play sport.
Music is distorted.

My independence has been stripped away. Every moment is lived in fear of a vertigo attack, even while I sleep.

I will *never* hear silence, or peace and quiet again, with the five impossibly loud sounds of tinnitus, incessantly torturing me.

Ménière's has taken everything from me ... *everything* ... except family.

I live for the moment when we can dissolve it with a cure!

Fleur

from the novel 'The Colour of Broken' with a Meniere's main character, by Amelia Grace, short listed twice to be made into a movie. #1 on Amazon numerous times.

Dear Me,

Be *kind* to myself ...

intentionally,
extravagantly,
unconditionally.

Love,
Me

Dear *M D*,

I hope you don't mind the informal address - "Ménière's Disease" seems so formal when you are such an intrinsic part of my life. Of course, when we first met I wasn't sure who you were and it took a while to realise you were not just a fleeting presence but one determined to stay around.

Do you remember that very first time I heard you? I thought the dishwasher had broken, you were so rudely loud!

And then there have been all those times you have sent me into a swoon, not able to walk or even move my head for a whole day at a time. In 2020, perhaps to distract me from COVID, visiting every few days was a bit over the top!

I have done many things to cope with our relationship. Having only decaf tea/coffee and white chocolate seems to have pacified your noise. Hardest though has been cutting down on salt. I miss eating out so much but, really, you are not a suitable dining companion.

I have resorted to medication to manage you and keep us on an even keel; thank goodness for Serc and diuretics. Some others have more challenging relationships with you although sometimes even ours can be a bit too much!

What does make a difference? Your communication skills leave a lot to be desired. Perhaps one day I'll find you have left me. Meanwhile, let's try to muddle on as best as we can - agreed?

Heather W
First met Ménière's disease in 2018

Dear *Ménière's,*

I have started this letter so many times, and it brought up so many emotions, that I have stopped writing to you! But I need you to know the impact you have on my life.

Everyday you are present, you never take a break and I never feel that you are not with me, and truthfully, it's very frustrating (to put it mildly).

Yesterday, you halted my plans with violent vertigo that had me floored and so, so sick, whilst today, you gave me a break from that, so I could go to work and battle through my day when I was feeling worn out from yesterday's attack.

I am so grateful for my hearing aids, that help me to gain what you took from me. I will always struggle with my hearing, even wearing them, but they give me a sense of taking my power back, like I win, you lose! But as soon as I take them out, the roaring in my ears let me know that you are always there. I used to long for quiet days, but I don't anymore. I have gotten a sense of peace without the quiet, and that makes me smile because it feels like I win and you lose that battle.

I do wish you would leave me alone, leave us all alone.

You are quite sneaky, in that you really are invisible to others a lot of the time, so it makes it difficult for people to understand what you are.

You Ménière's, is something I wouldn't wish on anyone, and I hope someday that you will disappear forever.

Jo

Left Ménière's since 2009
Bilateral Ménière's since 2018

From Darkness I Found My Light
Heather Davies
Acrylic paint

I was lost before Ménière's forced me to slow down and reevaluate my life, I learned to trust myself and to be true to things I want out of life.

Ménière's disease for the past 7 years

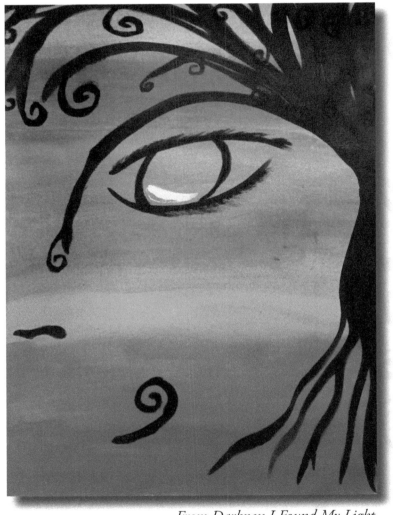

From Darkness I Found My Light
Heather Davies
Acrylic paint

Heavenly Father,

You've seen my every heavy tear laden with grief.
You've seen my breaking heart.
You've seen my despair.
You've seen my broken dreams.
You've seen my darkest of moments, stuck in a spinning world of vertigo, unrelenting tinnitus and hearing loss, a prisoner inside my own body.

You've heard my *why, why me*?
You've heard my pleads for it to stop.

You've seen me struggle to hear, drowning in embarrassment.
You've seen me walk like a drunk when I was sober.
You've seen friends and colleagues walk away.
You've seen me withdraw from social gatherings, from life.
You've seen me swallowed up in the hours and hours and hours of violent vertigo, unable to move, when I considered ending my life, numerous times.
You've seen me lose my balance and fall.
You've seen my absolute exhaustion from trying to live a normal life with an invisible, debilitating, devastating, insidious, incurable disease that chains us to a miserable existence where we question everything.
Everything.
You've seen me down on my knees, praying, a million and one tears streaming down my face ... praying.

And ... you were there, every time Ménière's launched a brutal, unforgiving attack. And You lifted me up.

In the darkness, You gave me Light.

You surrounded me with a loving, caring family and friends who didn't walk away.

You blessed me with the vision to see what is important in life. You sent a dream that told me that You see the beginning and the end of my life, and that my Ménière's disease will finish, and I will be released from it ...

And when I least expected it, You supplied my every need.

Thank You for always carrying me through the terrifying storms, for giving me hope when it felt like there was none, and for giving me a Light to hold onto in the darkness so I could find my way back home.

Forever Yours,

Julie S

P.S. Lord, we're ready for that cure or treatment that works now. I pray that You hear our millions of prayers. In the name of Jesus xx

God, grant me the *serenity*
to accept the things I cannot change,
courage to change the things I can,
and wisdom to know the difference.

Rose Reminder
Julieann Wallace
Photography

The lilac rose bloomed in my neglected garden and stopped
me in my tracks. The first thing that caught my attention
was the colour, and then as I moved closer I noticed the
unfurling of the petals that reminded me of the cochlear
of my inner ear. I leaned in, closed my eyes and inhaled
the fragrance - delicate floral notes, lily of the valley and
mimosa. Dreamy. It's the small things that are the big
things. Three things I was thankful for that day: *the lilac
rose, no vertigo, the beautiful day.*

Ménière's disease since 1995

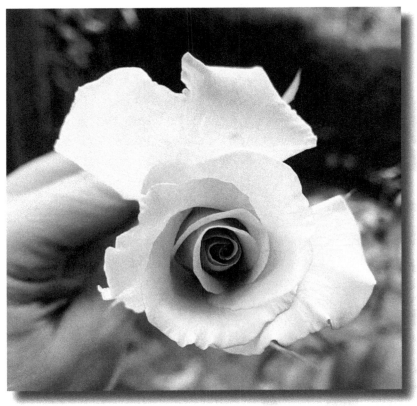

Rose Reminder
Julieann Wallace
Photography

Mr Ménière's,

I have a bone to pick with you.

On April 11, 2010, you hit me—hard—with more than a ton of bricks: sideways, smashing my plans to ride the Tour de France. I had trained hard, doing 300 to 400 hundred kilometres a week in the saddle, rain, hail and more rain. The aspiration of riding into Paris was dashed in one fell swoop. Thank you, Mr Ménière's, for nothing.

When I was diagnosed with Ménière's disease, the doctor's explanation was over the top of my dizzy head. I turned to Doctor Google to find, "This is your new life". "You will have reduced hearing, tinnitus will dominate conversations, you will rarely walk straight, you will call the toilet bowl a close friend as you vomit and vomit and vomit."

My doctor didn't have any literature to educate me on what to expect.

How do I respond to those changes in my lifestyle and personality? Where do I go to for comforting assurances? Because there is no cure, there is no relieving medicinal drug or natural therapy to even suggest relief of the overcoming darkness that engulfs my life each day. I have to choose to accept this is what I shall be for the rest of my life. The hearing aids I now have to wear, keep me in the loop, a little.

Over the past 13 years, I have not heard my doctor say, "There is a new way of dealing with this disease. Let's move down this pathway." Surely with 12 out of every 1,000 people with Ménière's in the world, some sort of research would be evident and be tested by worldwide associations on these affected people. The only alternative for many sufferers is "Get me out of this world".

When will the government recognise that urgent cure needs to be formulated to enable sufferers to live in freedom again?

"Burnout" is the only state we can look forward to. But still, that does not take away the feeling of - "is there another episode of retching and vomiting on the horizon?". Science has done so much to assist sufferers of other debilitating diseases, but are continually disappointed that Ménière's disease is not even considered to be on the list of - "it's time to help these people".

When I was involved in a bicycle/car accident in 2018, the brain specialist spent 90 minutes testing my new balance issues in order to confidently determine that the new issues were not being confused with my Ménière's disease balance issues. So I live with each, trying not to cover one issue with the other. I now walk with hiking poles to provide confidence that I won't fall into other people in my pathway. I wear a bright yellow lanyard with the message "I have a hidden disability. PLEASE BE PATIENT". The message is appropriate for my Ménière's Disease symptoms and my Traumatic Brain Injury.

Riding my bike was curtailed during the active period of Ménière's disease episodes. I did ride a little between then and the Traumatic Brain Injury, and then a couple of years after the Traumatic Brain Injury, I started to ride again. But only for a year before my confidence to ride went out the window.

So Mr Ménière's, please help by leaving my body. You have wrecked my aspirations and thrown me "under a bus". I look forward to days of equilibrium and stable feelings which will enable me to ride a bike again.

Charlie

Ménière's since 2010

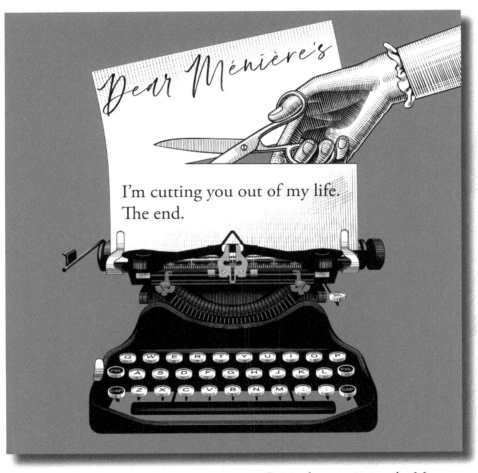

Dear Ménière's

I'm cutting you out of my life.
The end.

Original typewriter art by Maystra.
Teal background and text added by Julieann.

Dear *Ménière's,*

You came to me like a thief in the night and stole my life as I knew it and left me one I would come to know as a nightmare. I remember the doctor saying to me after a battery of tests and sounding pretty defeated, "Well, you have Ménière's."

I thought, *ok now, we fix it right?* No, not right.

I was told there was no cure but there were some things that I could do that would help me. He said, "Go on a low sodium diet, and no table salt."

NO TABLE SALT! I NEED TABLE SALT!!!

This time I followed the doctor's advice.

As I look back, I had been experiencing fullness in my ears on and off for years. My regular doctor said it was allergies and put me on allergy medication and a nasal spray, and I got better.

After a few years, the fullness came back. This time I was treated for what my Dr. thought was an ear infection. He prescribed antibiotic ear drops. The thought of putting ear drops in my ears scared the hell out of me. So, my boyfriend put the drops in my ear and I went on about my day.

Later that day, I told him I had a headache and was going to lay down. I never get headaches. When I got up I felt dizzy, you know, the dizzy feeling that happens and then you regain your balance … that didn't happen. Instead, I felt nauseous. The room started spinning. I fell to the floor and started throwing up, my eyes shut as tight as I could, holding on to the floor as if I was holding on to the side of a cliff.

I told my boyfriend to call an ambulance. He said he could pick me up and put me in the car and take me. I said, "Nooooo! I can't. Don't move me!" Any movement and I was throwing up and the world was spinning …

He called an ambulance. Two EMS guy's lifted me up, one under both arms and the other one under both legs. I was dead weight.

At the emergency room I was diagnosed with vertigo and given Valium to calm down the vestibular system and sleep it off. When I got up my symptoms were gone. I was told to follow up with an ENT.

I got my diagnosis pretty quick, which isn't the case with many Ménière's sufferers.

In the meantime, I continued to have attacks. It was horrible. The ENT ordered an MRI. I was given steroids to reduce swelling to rule out a brain tumor. No tumor, thank God.

The next step was to go to an audiologist for a hearing test. I had 60% hearing loss in my left ear, my affected ear. I also have ringing in that ear, tinnitus.

I've had two drop attacks in the last eight years. A drop attack is a "sudden fall to the floor without warning, and with no loss of consciousness"—a rare manifestation of Ménière's disease. *Hhmmmm that was fun.* Luckily, I had people there who caught my fall. I haven't had a drop attack in seven years but if it does happen, I know I will have someone there to catch me.

Many of us can't make it back to the workplace. Today I've taken a hobby and made it into a business. I'm a furniture artist and I sell my pieces in a store where I live and do commission work for other people. I'm able to make my own hours which is just what I need!

Rachael

Ménière's symptoms 2009. Diagnosed in 2015
Furniture artist: rachaelverhulst@aol.com

Escape
Lisa K. Champion
Photography

The day I saw the fog I walked to the beach with my camera. When I saw the fog on the lake it felt eerie but beautiful. It was quiet except for my constant buzzing I have in my right ear. But soon I started taking pictures and the joy and excitement made me forget about Ménière's, stress, tinnitus or anything negative going on. Photography is my escape.

Ménière's diagnosed in 2007

Escape
Lisa K. Champion
Photography

Dear *Ménière's Disease,*

We first met when I was 33 years old, you were much older and knew very well what you were doing ... I was not prepared.

We are not friends, and never shall we ever be!!

Your vertigo has spun my world upside down, in every sense of the phrase.

It took two long years to find out who you really are and to realise that you were here for the long haul.

Now that we have to live together indefinitely, I guess it means we have to tolerate each other.

I will live my quiet life, since you hate noise.

I will live in my darkened space to avoid all those bright lights you hate.

I will eat that low salt diet that you, oh so need!

Is that it?! Oh no, that's right, I forgot ... stress!! That's one of your biggest triggers isn't it.

So, in return, what will I get?

Fewer attacks with less severity ...

Can't you just go away all together, it doesn't seem fair!

I suppose because of you, I have learnt to make healthier food, I have turned to my art for an escape, I listen to my body a whole lot more and I look at life through a different lens.

I will never thank you, but I have accepted you!

Anouk Margot

2.5 years with Ménière's Disease

Dear *Ménière's,*

I learned as a young girl, in all fairy tales there are heroes and villains. Despite the strength and evil acts of the villains the heroes always prevail. You, Ménière's, are no different than the villains in these tales. You think you have stolen my life from me, when in fact you have opened my world like never before.

The tinnitus you sent to drown out my true north, now fuels my intuition.

The head and ear pressure you bring on, reminds me I am still here to make the most of my days.

The floor hugging vertigo reminds me to love mother earth as she cushions my fall.

The hearing loss encourages me to treasure the sweet sounds in my life.

The fluctuating sounds in my world nudge me to be more present.

The unsteady walk you have given me, has me cautious of the path I'm walking.

I will keep fighting for my happy ending, Ménière's. All while knowing I am the hero in my own story.

Heather Davies

Ménière's disease: 2017
https://open.spotify.com/show/3QVGI6zDyTrwjRQJ14mYuD
Instagram: @menieresmuse
menieresmuse.wordpress.com

VEDA
AMBASSADOR

Dear Me,

I must recognise my *limits*.
Don't *compare* myself to
people who don't have Ménière's
disease.

And ... connect to *nature*.
It's good for the soul.

Love,
Me

Dear Ménière's,

Stephanie

Dear Ménière's,

Was there a reason you chose me?
Am I not deserving of my hearing?
Am I not deserving of a life that is not surrounded by anxiety of vertigo, dizziness, drop attacks and whether my husband will finally leave me because I'm too sick?

I had to stop trying for a baby because you didn't like the drugs. Thanks for that.

Thanks for taking away the resemblance of a normal life from me at 19, and then deciding to go bilateral 10 years later.

I've never hated a person in my entire life but I HATE you more than words can say!

I hope you're proud of yourself how you can ruin someone's life just by existing!

Stephanie
Ménière's disease since 2017

261

Ménière's, Ménière's, you've attacked my ear.

It's hard to think. It's hard to hear.
My balance is shaky.
The floor feels quaky.
I hear noises no one else can hear.

Ménière's, Ménière's, you're ruining my life.
It's hard to be a good mother and wife.
I never know just when you'll hit.
And when you do it's just the pits.

Ménière's, Ménière's, I pray and shout,
For you to just pack up and please get out.

Helene Fryd Wenger

Silver Linings
by Sarah Mcpeak, submitted by Steven Schwier
Photography

I was present when this photo was taken. When I first saw it, I was captivated, curious, and overwhelmed by the symbolism that sucked me in. I could not stop staring at it. Every cloud has a silver lining I've heard, but I'm usually too busy each day climbing and trying to overcome the mountain of Ménière's. I can focus on the mountain or the cloud. I chose the cloud. It's beautiful, yet seems so out of reach. It's colors beckon me too reach out and enjoy it's majesty, yet the mountain stares at me, stirring my anxiety. The beauty is undenied in both the mountain and the cloud. But I chose the cloud.

Steven Schwier Ménière's disease since 2012

Silver Linings
by Sarah Mcpeak, submitted by Steven Schwier
Photography

Ménière's from Dark to Light

In the dark,
Curled up I lie.
In the dark,
Silently, I cry.

In the dark,
I learn about regret.
In the dark,
What fate have I met?

In the dark,
A decision to make.
In the dark,
I realize what's at stake.

In the dark,
I decide not to be.
In the dark,
Is no longer for me.

In the dark,
Focusing on the light.
In the dark,
This is not my plight.

In the dark,
I pool all my strength.
In the dark,
I am ready to go the length.

In the dark,
A mental change in the game.
In the dark,
Ménière's, I maim.

In the dark,
I take over,
In the dark,
Becoming a soldier.

In the dark,
I live no more.
In the dark,
I have closed the door.

Into the light,
I will soar.
Into the light,
I just want more.

Into the light,
Thankful I am.
Into the light,
Is where my life began.

Heather Davies.

Ménière's disease since 2017

Loving Myself with Ménière's
Heather Davies
Photography

When I first saw this tree I was focused on the fact that it had fallen down at some point in its life, most likely due to rising water or a hurricane. Then I photographed it. I stepped back, looked at the image in my screen and other things began to unfold for me as I changed my perspective. I saw the heart curved out of the top right sided branches. My gaze took me down to see an image of a woman embracing the trunk meshed in the spiral with her head resting at the top, and her arm curled up loving mother earth. I became very emotional. The tree had fallen over during some traumatic event, yet she hung on, she chose to continue living and thriving right where she was, enveloping the elements around her. More than that, she is beautiful because of her imperfections and her roots have grown stronger due to the events she has lived through. This tree, this mesmerizing tree represents me, she represents you, she represents everything we continue to battle through and overcome.

Changing my perspective living with Ménière's, has helped change my life.

Ménière's disease since 2017

Loving Myself with Ménière's
Heather Davies
Photography

Amy

Dear *Ménière's Disease,*

You've been around a long time—too long.

You've tried to beat me … you can't and you won't!

You've won some battles in this war of ours, even knocking me to the ground and bruising my face and body with your sudden drop attacks, embarrassing me, making me scared to go out in public and drive.

You've made the room spin for hours and made me dizzy for days.

You've confined me to my home and kept me from doing things I love to do for weeks, even months at a time.

I've awakened in the morning feeling woozy and hungover wondering how I'm going to get my son to school and make it through the day.

You've distorted my hearing and made sounds unbearable at times.

You've given me tinnitus that's kept me up at night and that I can never escape.

And the ear pressure that is so severe at times!

Some days it is all too much for me, BUT … I refuse to let you steal my joy and ruin my life.

I'm going to keep fighting you!

I'm going to keep searching for answers and ways to help myself and enjoy my life.

Amy

Ménière's disease since 2014

Dear *Ménière's Disease,*

Head is heavy
Ears are full
Cluster of mini spins
Tease me with what's to come...

I dare not go out for fear I will fall. Hell, it may happen within the confines of these four walls...

Oh, Ménière's, I hate you though I know it could be worse. For now, I am thankful that full on vertigo has not found me ...

When it does I am prepared to grasp my bed as if it will hold me down. The merry-go-round feeling where I cannot get off ...

Yet here I am trying not to panic as the mini spins once again take away my balance.

Still, I remember this too shall pass, though it feels as if forever it lasts.

I am a warrior battling my own head. Trying to outrun the beast as best I can. Living my life despite this disease.

Today, you can take me but know this, you will not break me!

Rita L Trushaw
Ménière's disease since 2000
mycrazylife2go.com
ritalsmith.com

Bloom
Libby Ryding
Pen, paper, bougainvillea flowers

Just like a flower petal can become fragile and fall,
Ménière's can cause us to become dizzy and fall. Remind
yourself it's okay just hang on and stand tall. Just like a
flower we will flourish and bloom over and over each day.

Ménière's has pretty much affected every single aspect of
my life over 35 years plus that I've been living with it and
the thing that has kept me going was working with my
flowers.

Ménière's disease for 35 years +

Bloom
Libby Ryding
Pen, paper, bougainvillea flowers

A THIEF CALLED *Ménière's*

Hello *Ménière's,*

Since the year 2000 you have incapacitated me for many days of my life.

I am letting you know that you are still with me after 23 years. I had hoped by now that you would have disappeared and let me get on with my life without lurking in the background. I could not open this letter with "Dear Ménière's" as there is nothing dear, or nice, about you.

I cannot count the number of days that you have inconvenienced me with attacks of vertigo, vomiting, inability to stand and consequently confined me to bed. Most of the time you seemed to come on for no apparent reason. I ask myself what happened in the day or so before the attack? Was I stressed, did I consume food containing too much salt or sugar, drink too much caffeine (I have one coffee and one tea - sometimes herbal - a day), did I not sleep well? Most of the time I cannot say yes to any of these questions.

In the early years of the disease you literally turned my world upside down. When the vertigo hit I had no sense of which way was up or down, the whole room (ceiling and walls) was rotating violently. The slightest movement would make me retch or vomit, there was a sense of fullness in the left ear (Ménière's affected ear), low tone hearing loss and tinnitus. Initially, the tinnitus was spasmodic but became non-stop from 2004 to present, sometimes both a high-pitched sound and pulsatile tinnitus in unison.

You incapacitated me for many days of my life, where I was not able to go to work, socialise or do basic tasks. "Recovery" in the sense of being able to do things like house cleaning and shopping can take up to a week after the vertigo subsides.

A cluster of Ménière's attacks in 2009 brought on two additional sensations, that of chronic imbalance and hyperacusis. Standing and talking to someone became difficult and standing at the bus stop was not easy with me shuffling around to maintain an upright position.

Since 2009, I find it hard to recall a day during which I have not had this sensation of imbalance, which at times makes me feel as though a vertigo attack may be imminent. I know I am not functioning in a normal way. I am conscious of my movements, such as turning, bending or getting up and going down, for fear of doing a "wrong" movement and also walking too quickly which may set the vertigo off.

I still wait for the day that researchers will be able to say definitely what causes Ménière's disease and most importantly find a cure(s) for this debilitating disease.

Regards,

Esther

Ménière's disease since 2013

Desired Peace
Donelle Wilson
Acrylic paint on canvas

Ménière's Disease.
Annoying. Irritating. Unfair.

As the waves hit the shoreline, peace overtakes my thoughts. I can breathe again. I am able to focus on the louder than tinnitus, sounds in nature that God has provided for me to enjoy. The waves crashing, the birds chirping, the wind rustling the grasses nearby. Even though it is sometimes hard to find a focal point while walking on the beach so I don't get dizzy, it is so worth my efforts! I am rewarded for facing my fears and pushing through to the finish line daily. I can see myself approaching this scene wearing my favorite suit and sunglasses. It is absolutely wonderful. I am curious about the island in the distance and see it as a goal in life to make it to that Island of complete healing. I want to explore it with the awe and wonder as a child of God enjoying all He has to give, I will do that on the journey to the Island as well. As I have been on this journey for over 18 years!

Ménière's disease for 18+ years

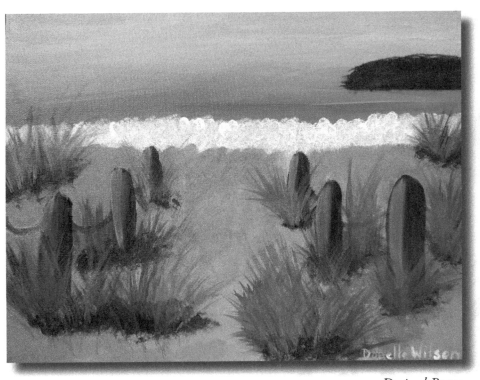

Desired Peace
Donelle Wilson
Acrylic paint on canvas

To the horrible disease that has affected *far too many people*,

Ménière's,

I hate you!!!! I could have died because of you. The first time you reared your ugly head you sent me falling into traffic. You could have left my children without a mother.

You have been controlling my life for 25 years and I want you gone.

You have taken my time away from family, friends and taken away my independence. You rob people of their mental health and their careers.

I miss my old life. You destroyed that. I had to mourn my old life and accept the new one that you have left me with.

I was diagnosed with you 25 years ago and re-diagnosed with bilateral vestibular hypo-function 12 years ago. Nothing has been the same since.

Everyday is a struggle and I pray everyday that when I wake up I will feel better than the day before. You must hate me because it doesn't happen. Thank God for my family. They keep me from going insane.

Screw you and your ugliness. You really piss me off. You're not going to take me right down though. Nothing will. I will make it work. You will no longer dictate my happiness. That you can't take away.

Your enemy,

Debbie Alles

Ménière's disease for 25 years

Dear *MD*,

dizziness sideways BREATHE help unstable diarrhea
sweating floor VOMIT stillness bed recovery sleep
exhausted ringing hearing loss doctors referrals ENT
appointments health spinning foggy
nervous panic pills fluid crying steroids HOPE ear nausea FUCK
oxygen travel tests VERTIGO children PTSD worry future
BALANCE shaking eyes dizzy earplugs vitamins books puking
sodium WTF pain rehab walking wellbeing searching Internet
DIZZY alone journal doubt LIGHT movement neck sadness
nystagmus MRI drug PEACE medicine viral reading plan hungry
bored scared survival shit messy help fear ANGER why FAMILY
weight loss depleted stiff throw up headache alone throbbing shame
children guilt rotating immune vestibular testing ENDLESS sick
infection tired unsteady tinnitus darkness disorder EMPATHY
movement labyrinth neuroplasticity pressure nausea
no cure INVISIBLE connection isolation fear
unrest sidelined SURRENDER progress remission bilateral
diet hearing aids allergies brain fog relentless LOVE unforgiving
silence RESILIENCE shadows growth cycles forgiveness
TRIGGERS expensive research online no cure strength
CONNECTION friends ongoing sleeping sensitive STRESS
dysfunction inner ear unsteady isolation confusion diagnosis

SELF LOVE

Sasha

Ménière's since 2022
Facebook: sasha.campbell.31
Instagram: @sashalcampbell

Bedside Companion
Neil Canham
Photography & digital

When bad vertigo hits, I've described it as "world-spinning vomit hell". Paraphrasing *The Hitchhiker's Guide to the Galaxy*, "you should always know where your bucket is". After a series of particularly violent attacks lasting hours, I felt compelled to create this image - showing the bucket, raised so that no head motion is needed, along with rescue meds. Humour is absolutely necessary, otherwise despair would undoubtedly win. I also wanted to create something for the community that might help raise awareness and cheer folk up. My wife recently bought me a nice sparkly new bucket to replace the "builders" one in the image - it was one of the best most thoughtful presents I've ever received!

Ménière's disease since 2013

Meniere's means

Always knowing where your bucket is

Bedside Companion
Neil Canham
Photography & digital

Dear *Ménière's Disease,*

What's going on?
There's weird noises in my ears, they're coming on strong.
Loud, never ending, I fall, sometimes drop,
It's causing havoc, it's making me spin,
My world is rotating,
Please, make it stop!

There's tinnitus, vertigo, brain fog,
Headache and pain,
You make me trip, now I'm falling again.
You sneaked uninvited into my life,
Causing so many tears, so many fears.

When I fall into bed exhausted, needing rest,
You rob me of sleep making it harder to cope,
While you cruelly persist trying to take all my hope.

Ménière's, you beast, I hate all your ways!
There's so much confusion, so much malaise.
The long lonely nights when I lay wide awake,
Silently cursing you, I want you to quake.

You've stolen my hearing, confidence, smile and my joy,
My relationships, independence and freedom to do what I enjoy.
To travel, work, swim in the sea,
You've really just taken so much away from me.

I've felt isolated and alone for ever so long,
But kept fighting back hard to not let you win.

Finally I've found my own little tribe,
Along with more hope and new ways to cope.
These Vestibular Warriors are positive and strong,
And we're all on a mission I'm delighted to say.

You're pernicious, poisonous, painful, persistent,
We hate you Ménière's and we are on our way.
Your days are numbered!
So bugger off Ménière's we've got living to do!!!

From Vestibular Warrior,

Healing Helen

Ménière's survivor of 35+ years and counting!

Dear Me,

Look for the *small things*.
Those become the BIG things ...
the opening of a flower, the stars, the
twinkle in someone's eye, the smile,
the hug, the ocean, the feel of rain,
the moments when you feel okay.

Love,
Me

Dear *Ménière's,*

In 2020 I had been suffering this cruel disease which I called the monster for eight years. I had given up hope, almost lost my family, and lost most of my friends, not to mention my health and sanity. My future was a black hole. Somehow I decided to fight back. I made a rash decision to ride an e-bike from Denver Colorado to Columbus Ohio, with help from my brothers, Dave and Brian, we completed the 1,400 mile journey. 1,400 miles. I had no idea what to expect. I'm not an avid cyclist. Yet, I wanted to bring awareness to our plight. I learned the value of family, friendships, and in the end to love myself no matter what life handed me. This is an excerpt from my adventure:

On The Vertigo: One sick man's journey to make a difference.
Never stop fighting, never give up.
You are not alone.
Peace Out!

I have to talk myself into moving at all, really, because this is an anxiety like no other. You have to understand—I'd rather die than sit up. Sitting up will cause the world to spin more violently than it already is, and if it changes direction I will definitely start vomiting. Just the thought is paralyzing and scary. I always cry at this point. I'm terrified to move. I explain to Dave, my plan to get into the camper through tears of humiliation. Dave and Brian will next have to reach under my arms and support me into the camper and to the cushioned bench. After a couple minutes of inner argument, I force myself upright. I fall headfirst into the back of the camper and rest my head on the cool bumper. Step one completed. I wait for myself to steady a bit. The feeling of time is slipping away. How long have I been in this position? Minutes? An hour? I fantasize about running to Brian's truck and backing over myself to make this all stop. Emmitt records Dave

and Brian struggling to pour me into the camper and it ends up being the most watched video of the trip to that point. I'm not talking viral numbers such as a cat playing the piano or some shit, but it was viewed over 10,000 times around the world on our social media sites. That may sound awesome to most people, but I was ashamed and embarrassed. Losing all of your cognitive abilities is not something to be proud of. It's also something most people have never seen. It's scary to watch. And many Ménière's sufferers said they had to turn it off. Others said they cried through the whole episode. These people knew exactly what I was feeling and it's beyond heartbreaking to watch. I finally get inside the camper and flop onto a padded bench. Dave and I make a couple videos explaining my situation and after that I surrender. I put my cold-snap towel over my face and let vertigo carry me away. You may think I'm being a bit over dramatic, but let me tell you, I'm not. I'm not even coming close to explaining what this actually feels like. There are no words. A vertigo attack is intangible. It has no timeline. It's just pure suffering that can't be explained with words. How can you describe the indescribable? I'm trying my best to do it here anyway. There are thousands of people experiencing vertigo attacks around the world as I write this, and my heart goes out to each and every one of them. If there's any good thing that could come from my humiliation and pain, it'd be to let other Ménière's sufferers know this, and to feel it deep in their bones: *You are not alone.* There are others of us out here and we are with you. *You are not alone.*

Bite me, Ménière's,

Steven Schwier

Ménière's disease since 2012
Instagram: @onthevertigo
Facebook: Ménière's: On the Vertigo
On the Vertigo.org

Freed!
Julieann Wallace
Digital on Procreate

In 2019 I created a quadtych of art for an art exhibition showing the journey of Ménière's disease. This is the final piece of the 4 artworks, depicting being released from the Ménière's prison. The bird who could not fly, now flies to freedom, dropping the swirl of vertigo from its body for good. Hearing is restored, represented by the treble and bass clefs and the sun is shining more brightly than ever, depicting happiness. I like to think that freedom from Ménière's disease will be in our lifetimes, like our lives being restored to what they should be.

Good news is coming.

Ménière's disease since 1995

Freed! ♡

*Once captive, now freed from
the symptoms of Meniere's Disease* ♡

Freed!
Julieann Wallace
Digital on Procreate

To the *Ménière's* Monster, who is living in my doofus ear,

I am the person you decided to make your home since 2010.

As a Clinical Psychologist, working in a solo private practice, I have been affected very much because of you. Quite frankly, I had to learn to live with you as my boss.

I decided a few years ago to purchase some of *Julieann Wallace's* books she had written for children, about you, Mr. Ménière's Monster. I sent the books to the different Medical Centres and primary school libraries in my region. My goal was to support the author in the great work she has done for Ménière's Disease research, as well as to share some information about the disease.

I printed and pasted the following little poem in the books:

Dear Reader

Many persons suffer many years
With a disease called Ménière's
It's really not easy
As they may feel quite queasy
When they want to be busy
They may feel too dizzy
Their ears may hear ringing
Like cicada choirs singing
They may need to go slow
Because of spinning and vertigo
This book was bought
With the goal to support
Research in Ménière's
As it affects too many ears!
Let's hope they find a cure
That would help for sure!
Thank you for the time you took
To read this wonderful book!

Marie

Ménière's diagnosed: 2010

Joy
Lisa K. Champion
Photography

Walking to the lake with my camera is therapeutic to me. It helps me escape Ménière's, my other illnesses and other stresses that I'm going through. This day was special. I was feeling pretty good and the sun was shining down upon me as I walked down to the lake. Seeing this swan and capturing it with my camera was priceless to me. Priceless, not because I want money for my pictures ... I don't, but because the pictures bring me joy and smiles to me and to the people I share them with.

Ménière's can't stop *The Girl Behind The Lens*.
Ménière's diagnosed in 2007